The
Age of Louis XV

The
Age of Louis XV

Alvar Gonzalez Palacios

Paul Hamlyn

LONDON · NEW YORK · SYDNEY · TORONTO

ISBN: 0600 012107

Translated by Henry Vidon from the Italian original

Il Luigi XV

This edition © 1969
The Hamlyn Publishing Group Limited
Hamlyn House,
The Centre, Feltham,
Middlesex

Text filmset in Great Britain by Keyspools Ltd,
Golborne

Printed in Italy by Fratelli Fabbri Editori,
Milan

After the death of Louis XIV in 1715, a radical change occurred in French society. The last years of his reign had been a period of austerity and solemnity marked by an etiquette which verged on the liturgical. Even in the sovereign's absence, for example, one had to bow to the royal throne or the royal bed. Wearied of this existence which was partly due to the influence of 'la fausse prude' as Madame de Maintenon was maliciously—and not unjustly—nicknamed, the court lost no time in changing both mien and manners.

The young heir, Louis XV, who was only just five years old at the time of Louis XIV's death, was taken to live at the Tuileries in the heart of Paris, and the Regency was entrusted to a member of the younger branch of the reigning family, Philip of Orléans, who continued to live in his own residence, the Palais Royal. Thus Versailles, the building by now nearly completed, was without a king until 1723 when Louis XV came of age. The personality of the Regent

himself had a considerable effect on the fashions of his day. Intelligent, cultured, great lover of the arts, he proved essentially a lover, and nothing more. He could have let himself be led, like *le Roi Soleil*, by a profound sense of dynasty, a lofty idea of his own historic mission. Faced with the choice, he opted unhesitatingly for his own amusement. As a result the aristocracy left Versailles for their *hôtels particuliers* in Paris or their châteaux in the country, and abandoned themselves to an outburst of high living in which the excesses of the debauched inevitably gave rise to gossip. The healthy economic situation and the peaceful state of Europe was certainly no hindrance to this new way of life.

As soon as the young King was installed at Versailles, he showed that he intended to follow the gay path chosen by his cousin, not the stately steps of his great-grandfather. He had been married for some years to Maria Leszczynska and had remained faithful for a while, having several children by her. But the irritating, rather silly Queen did not interest him much, so he went elsewhere in search of that *joie de vivre* and *esprit* so conspicuously absent from the royal bed.

First, it was the turn of Madame de Mailley and her sisters, but round about 1742 the King met the woman who was to stay by him some twenty years, the woman who, if she did not actually alter the destiny of France, undoubtedly exercised a decisive influence on French art, for she contributed largely to the creation of what we call nowadays the Louis XV style. This woman was, of course, Madame de

Pompadour. A daughter of the *petite bourgeoisie*, she was not only quick to learn the manners of the court but transformed the court itself, such was the effect of her personality. A woman of many talents, she sang, danced and acted at royal entertainments; she knew how to paint and used to make engravings from the compositions of Boucher, her master, and follow with great interest the manufacture of Sèvres porcelain. She read the Encyclopedists and was acquainted with the more compromising and serious works of the day, volumes such as *L'Esprit des Lois* and the others with which she is surrounded in the portrait of her by La Tour. She followed the activities of the cabinet-makers and was always commissioning new furniture from them. She gave her protection to the leading sculptors of the day like Falconet. She never failed to keep up with the latest fashion. In a word, she became *arbiter elegantiarum* of the age and, although her influence in politics sometimes proved unhappy, she is undoubtedly the key to an understanding of French taste in the first half of the 18th century. She gave it just that exquisitely graceful and feminine touch which still fascinates us today. She was a passionate collector, and when she died in 1764 (Voltaire went into mourning because he considered her a philosopher), the public auctioneers had to work daily for eight months to dispose of all that she had amassed.

The Marquis de Marigny, Madame de Pompadour's brother who was made superintendent of the royal buildings, exercised considerable influence by his moderate taste especially during the so-called

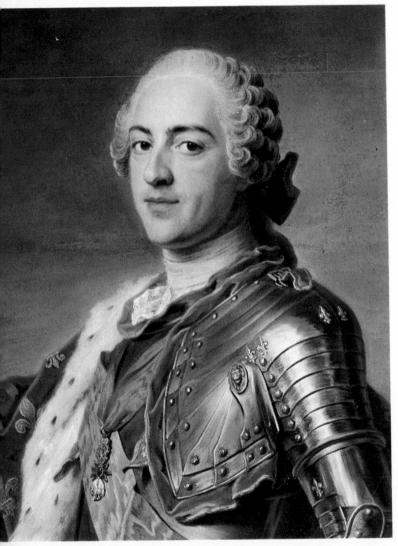

1. Maurice Quentin de La Tour (1704–1788). Portrait of
Louis XV (1748). Louvre, Paris.

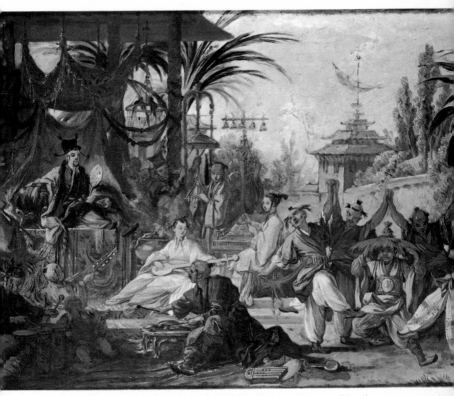

2. François Boucher (1703–1770). Chinese Dance. Musée des Beaux Arts, Besançon.

1. Maurice Quentin de La Tour (1704–1788). Portrait of Louis XV (1748). Louvre, Paris. This pastel, besides being one of the most faithful likenesses of the sovereign, is a good example of La Tour's work. It was just this type of portrait, combining shrewd observation with a certain formality, that made him the favourite painter of high society and the aristocracy.

2. François Boucher (1703–1770). Chinese Dance. Musée des Beaux Arts, Besançon. The taste for *chinoiseries* and the exotic in general was one of the dominant characteristics of the age of Louis XV. Boucher was the most representative, if not the leading, painter of his day; he painted this and smaller scenes as cartoons for tapestries of which a series was sent to the Emperor of China in 1762. The other cartoons are also preserved in the same museum.

3. Maurice Quentin de La Tour (1704–1788). Portrait of Madame de Pompadour. Louvre, Paris. The influence of Madame de Pompadour on the political and artistic life of France between 1743 and 1764, the year of her death, made itself felt down to the smallest detail. Madame de Pompadour was awake to every variation in taste, to anything new; she protected leading artists and befriended writers and philosophers, so much so that the Goncourt brothers spoke of 'France Pompadour'.

4. Lacquered papier mâché vase with carved gilt bronze mounts in the Duplessis style. *c*. 1740–1750. Musée Nissim de Camondo, Paris. Collecting Chinese porcelain was already popular in France in the reign of Louis XIV. Since such pieces were extremely rare and costly, they were often copied either in porcelain or in lacquered papier mâché.

3. M. Q. de La Tour Portrait of Madame de Pompadour.

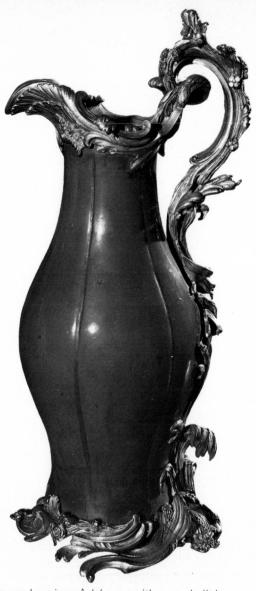

4. Lacquered papier mâché vase with carved gilt bronze mounts in the Duplessis style. *c.* 1740–1750. Musée Nissim de Camondo, Paris.

'transition' period between Rococo and Neo-classicism. But the King himself, often more concerned about the clothes in his wardrobe and the furniture in his châteaux than affairs of state, showed the greatest interest in every aspect of art and fashion. Fashion was the tyrant of the age; even chairs had to conform to its caprices—the enormous pannier-shaped gowns worn by the women obliged chair arms to be placed further back so that the ample folds of multi-coloured silk would fall gracefully over the *petit-point* tapestry with which the seats were upholstered.

A piquant, picaresque levity seems to have taken hold of everything, inviting not the 'enlightened' leisure of the .philosophers but rather that of the voluptuary and pleasure-seeker. Even the fashion in houses changed. The grandeur, the exaggerated cult of perspective and the imposing rows of salons gave way to a preference for the warm intimacy of small apartments and compact rooms decorated in fresh, gay patterns, instead of the heavy gold and silver brocades which had been fashionable under the late sovereign. Everything was fresh, bright and, above all, comfortable, if a little precious. Yet despite all its praiseworthy results not only in living-quarters but in thought or in the caustic irony of a Voltaire, this passion for light and clarity had irreparable consequences. One such was the destruction of stained glass windows in Gothic churches, an event by no means rare, and all just to banish 'profaning' gloom.

The 18th century was certainly no respecter of the past: but if this King could burn the Sun King's

marvellous embroidery merely to recover a few pounds of gold and silver, in Italy, a century before, the Barberini had melted down the bronze in the Pantheon for Bernini's baldacchino in St Peter's. *Sic transit gloria mundi!* There is no call for us to be greatly shocked. Just think how much is being destroyed throughout Europe today in the name of the so-called 'necessities of modern life'. Far more than during the 18th century, no doubt. However, these new apartments, these delicate caskets, if you will, were filled with *objets d'art* of every kind. Society turned collector with a mania for anything that took its fancy, the elegant, the refined, or the curious. Everything was collected; drawings, paintings, porcelain, shells (for this last item the merchant Gersaint, a friend of Watteau, made an annual trip to Holland). The King used to give foreign monarchs diamond-studded snuffboxes adorned with his portrait, but he was only too glad to receive Chinese porcelain or Oriental lacquer-work in return.

That was another craze of the day: the exotic. The land of China first and foremost, but a China *sui generis*, a China powdered and coquette, an almost imaginary China which gave its lacquer to the furniture created by Parisian cabinet-makers, its magnificent porcelain vases to highly skilled French goldsmiths who mounted them with bronze in pure European style. People not rich enough to own genuine Chinese things had them copied. Vases were imitated in lacquered papier-mâché, like the one now in the Musée Camondo, Paris (plate 4); lacquer-work was imitated by the Martins; thousands of little

Chinese comic-opera figures populated the porcelain of Chantilly and Sèvres. Watteau himself used Chinese themes for his decorative panels in the *Château de la Muette*. In 1762 Louis XV sent the Emperor of China, Chien Lung, six wall tapestries copied from Chinese cartoons especially drawn by Boucher. The craze had reached its height.

But *chinoiseries* alone did not appease this curiosity about the oriental world. A Swiss painter with a French education, Liotard, went off to Constantinople where he remained for some years living like a subject of the Sublime Porte (the Ottoman government). When Liotard returned to France, he brought back with him many paintings of Turkish subjects, and these *turqueries* had a striking success. Madame de Pompadour at once commissioned Carle van Loo to paint her portrait as a sultana for a *dessus de porte* in her château at Bellevue. Other artists went to Russia, and the painter Le Prince had some success with his *russeries*. It was this love of the exotic which made an Italian painter, Giuseppe Castiglione, go to China where apparently he gained the protection of the court. By the same token, Montesquieu published his *Lettres Persanes*.

Politically all was not well; the reign of Louis XV was in this respect a complete failure. The War of the Austrian Succession brought France nothing but financial loss. The Seven Years War cost practically the entire colonial empire. But what did it matter? '*Après nous, le déluge.*' Whole fortunes were spent on fitting up a folly or building a Chinese pavilion. In the Hôtel de Soubise, redecorated by Boffrand, the

excessive luxury was almost vulgar—a vulgarity of a particular kind, it is true, when one remembers that the Adams (the French sculptors, not to be confused with the British brothers) had a hand in the work, as did also Lemoyne, Natoire, then at his best, and Boucher, besides the finest stucco artists of the day. The Duc d'Aumont would have ruined himself through his collection of Chinese vases had he not enjoyed an immense patrimony. The King's minister, the all-possessing Duc de Choiseul, went bankrupt in spite of having married one of the century's richest heiresses, the daughter of the financier and collector, Crozat. And all because of his château at Chanteloup. Not even the foundations remain today but, in its time, it was one of the finest dwellings in Europe. When the Duke was 'exiled' to this domain of his—he fell into disgrace through the lack of friendship shown him by Madame du Barry, the King's new favourite— the life he led there almost rivalled that at Versailles, for the Château de Chanteloup housed a real court. 'The dwelling was so magnificent,' wrote a contemporary witness, 'that the whole province, the nearby towns, even the court itself remained dazzled.' And Madame du Deffand, whose salon was one of the foremost of the day, recorded that 'to go to Chanteloup means finding yourself in the best society, enjoying the best entertainments, giving yourself *bon ton* . . .' She was right. It lacked none of those things, nor the Chinese pagoda, the paintings by Guido Reni, Tintoretto, the Carracci and Boucher; the spectacular gardens; letters from Voltaire, then at Ferney in Switzerland; even the endless but delightful intrigues

were not missing. In fact it is said that just such an affair sparked off Beaumarchais' masterpiece, *The Marriage of Figaro*. Every character in the story had its counterpart in real life.

But one must not imagine that the reign of the '*Bien-Aimé*', as Louis XV came to be known, was just an epoch of frivolity and excessive luxury. On the contrary, the century in which he lived was the century in which Voltaire wrote: 'Minds enlighten themselves much more than in all the preceding centuries.' It was also the epoch of the great Encyclopedists—D'Alembert, Diderot, Helvétius. In 1751, they started publishing that monumental work which, in some ways, started the modern way of thinking. Voltaire was a contemporary of the King. Rousseau, whose ideas about equality and a 'return to nature' opened the road for the early Romantics, was slightly younger. With his *Esprit des Lois*, Montesquieu kindled much significant political thinking, while the names of Réaumur and Buffon have become milestones in the history of science.

Not that all this happened with the King's personal encouragement. Louis XV had a pronounced dislike for the political and social thought of his times and, as a rule, ignored the omens with which he was surrounded. If anything, he showed more curiosity about scientific questions. Nevertheless, it was precisely during his reign that men began to think seriously of political and social questions, and the importance of this can escape no one. The ideas aired in Louis XV's days supplied the basis of the thinking which made possible the Revolution of 1789.

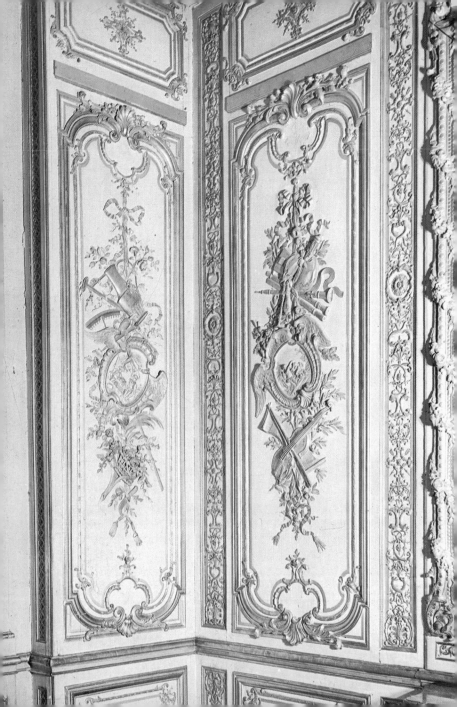

5. Jacques Verberckt (1704–1771). Boiseries in Madame Adelaide's music room, Versailles. The extraordinary musical trophies in these carved wooden panels were designed by the architect Gabriel, and made by the Flemish sculptor and *ornemaniste* (stucco artist) Verberckt who started working on them in 1753. In the winter of 1763 the child prodigy Mozart played before the delighted royal family in this room.

6. Jacques Verberckt (1704–1771). Boiseries in the Cabinet de la Pendule, Versailles. These boiseries were made in 1738 and are considered to be some of the most successful expressions of *rocaille* in the delicacy and grace of the decoration which has none of the florid excesses that developed later.

7. The Council Room, Château de Fontainebleau. Redecorated in 1751. The paintings in blue and pink *camaïeu* framed by garlands of flowers are by C. van Loo and J. B. M. Pierre. The ceiling is by Boucher.

8. Jean Baptiste Oudry (1686–1775). Decorative panels formerly in a mansion situated at 9 Place Vendôme, Paris. Musée des Arts Décoratifs, Paris. This room is a good example of the new interiors created by French architects in the days of Louis XV. Rooms were reduced in size to make them more intimate and comfortable. The walls were lined with panels of wood and sometimes these were decorated by well known artists such as Oudry.

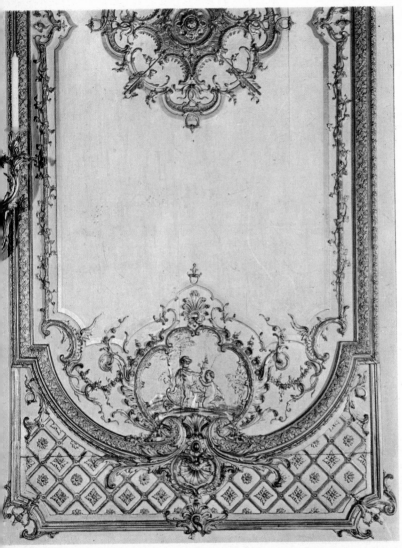

6. Jacques Verberckt. Boiseries in the Cabinet de la
Pendule, Versailles.

7. The Council Room, Château de Fontainebleau.

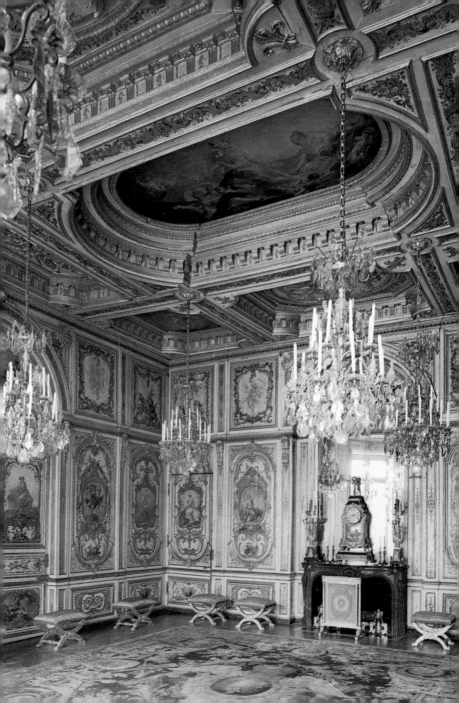

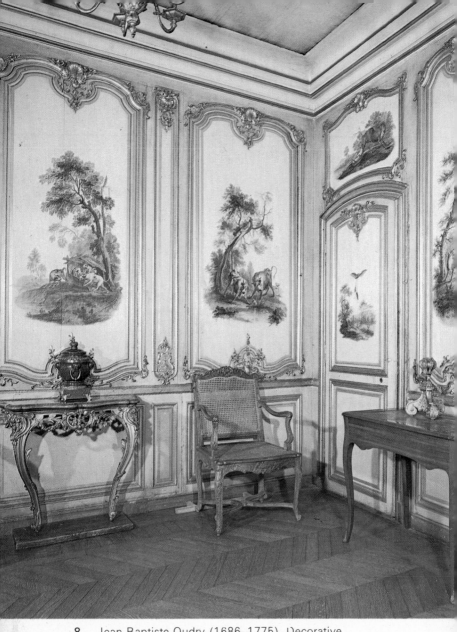

8. Jean Baptiste Oudry (1686–1775). Decorative panels formerly in a mansion situated at 9 Place Vendôme, Paris. Musée des Arts Décoratifs, Paris.

This does not mean that we should ignore the ideas and institutions encouraged by the King or his immediate entourage. Louis XV himself always knew how to select the best of contemporary art. Sometimes he spotted talent even beneath what looked like impertinence, as in the case of the painter, La Tour. Sometimes he protected and aided it to the utmost as he did where Boucher was concerned. Whether to satisfy his personal vanity or not, Louis XV encouraged French artisans and amused himself by making decorative objects with his own hands. He also supervised the decoration of his own apartments, often with results of unsurpassable magnificence and grace—the salons of Versailles, for instance, where the proportions and elegance of Verberckt's *boiseries* were far from excessive (plates 5, 6). This is more than can be said of those chosen by many members of the aristocracy for their own châteaux. Thus, Versailles, residence of the monarch, became a model palace envied and copied by every European sovereign. The palaces of Schönbrunn in Vienna, Caserta in Naples, Colorno in Parma, Potsdam in Berlin, La Granja near Segovia; the Residences at Koblenz, Karlsruhe, Bonn, Mainz, Stockholm; Stanislas Leszczynski's château at Lunéville, or that of the Tsar—these were all adaptations of or variations on the theme of Versailles.

Louis XV always protected the interests of his Académie des Beaux Arts. To the best pupils he gave bursaries so that they could go to Rome and study at the French Academy there, in the Palazzo Mancini under the guidance of the director, himself an

Academician. The story of the Palazzo Mancini and the Academy which it housed is very much the story of contemporary French art.

From 1737 on, at first annually, then every other year, large exhibitions were held in Paris, Salons as they were called after the Salon Carré in the Louvre where they were held. On these occasions, the academicians themselves—almost all the major artists—exhibited their own works. To follow these Salons is to follow the development of the artistic ideas of the age, and, to some extent, one can do this under the rather partial but always intelligent guidance of Diderot, who chronicled the Salons for a long time. In addition to the Salon proper, there was also what one might call the Salon des Refusés, an exhibition of paintings in the Place Dauphine held every year but for one day only. It was known as the Young Painter's Exhibition, and some of the future glories of the century displayed their work there, among them Chardin. At that period of history, there existed neither museums nor collections open to the public. The Salons, therefore, were the first exhibitions of paintings in the modern world.

We should not forget a certain human side to the character of Louis XV. His incredible vanity, his indolent sensuality and sloth hid a certain feeling for other people which may or may not have been due to the spread of philanthropy in those days. It was this which provoked those famous words on the eve of the battle of Fontenoy: 'But the blood of our enemies is human blood. Our glory is to spare it.' In Louis XV's time, love for the individual triumphed, which

was often shown by curiosity about the appearance and character of a person. This is evident not only in this famous utterance but also in the little facets of fashion, the craze for silhouettes, for example—portraits in profile, black cut-outs on a light background reproducing faithfully the features of a likeness.

The splendour and magnificence of Louis XV's court were truly imposing. One bitter winter, Madame de Pompadour filled the flowerbeds of one of her gardens with porcelain flowers and sprinkled scent in the air to complete the illusion. And let us not forget the theatrical spectacles or the beautiful firework displays staged by, say, Servandoni, architect of the severe façade of St Sulpice.

An important part was played by architecture in establishing contemporary taste. All told, it may have been the art which was least carried away by the bizarre, asymmetrical spirit of Rococo, but it was responsible for the detailed perfection of interiors. And another fact not to be overlooked is that many architects produced collections of designs which inspired all manner of craftsmen, from cabinet-makers to goldsmiths, not forgetting workers in iron and steel, the men who fashioned the magnificent balustrades of the stairways at Bellevue, for example, or those once at the entrance of the Cabinet du Roi. The designs for them are attributed to Nicolas Pineau, a pupil of the architect Robert de Cotte, and they are now in the Wallace Collection in London.

An exceptionally interesting example of urban planning can still be seen at Nancy. The two squares and the oval courtyard designed by Heré intercom-

municate through a magnificent triumphal arch, erected by Stanislas Leszczynski in honour of his son-in-law, Louis XV. Both the squares and the courtyard are adorned with wrought-iron palings crowned with gilded Rococo motifs. They are in perfect harmony with the façades of the surrounding buildings designed by Boffrand, and spread like elaborate tendrils throughout the unit, twining along the balconies, around the fountains and the statues in the niches (plate 11). Like the metalwork in the local cathedral, it was the creation of Jean Lamour, and is one of the highlights of *rocaille*, the dominant decorative theme in the first half of the 18th century.

But what is *rocaille*, this leading motif of the Louis XV style? One finds it everywhere, now more, now less—running through the hilt of the royal sword, the handle of a jug, the bronzework on a commode, the draperies of a goddess painted by Boucher, the embroidery on a dress. Some people have defined it as the solidification of the movement of the crest of a wave, others as the idealisation of a motif from the vegetable world. In essence, it is ornamental design derived from motifs found in nature, but altogether abstract from the decorative point of view. *Rocaille* began to insinuate itself into French art during the last years of Louis XIV's reign, went from strength to strength under the Regency, reached its greatest development between 1730 and 1740, then slowly weakened towards the middle of the century, the period usually called 'transitional' (from the Louis XV style to the Louis XVI). The exaggerated development of the *rocaille* motif was called Rococo, and this

9. Box mounted in gold. Musée Cognac-Jay, Paris.

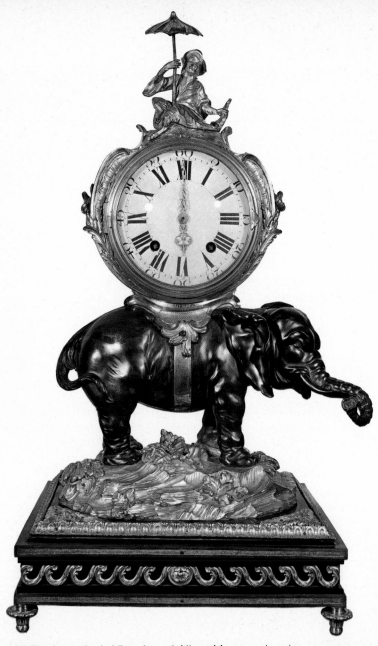

10. Elephant clock. Victoria and Albert Museum, London.

9. Box mounted in gold. Musée Cognac-Jay, Paris. The 18th century's acquired taste for luxurious little objects is demonstrated in the captivating odd boxes and snuffboxes made in gold and silver and frequently adorned with miniatures. Large numbers of these boxes still exist because, being so small, they escaped the decree obliging people to melt down most of their gold and silver possessions.

10. Elephant clock. Victoria and Albert Museum, London. This exceptional piece is another example of the fashion for the exotic, especially for *chinoiseries,* with the strange monkey figure perched on top with his parasol. The magnificent bronze-work is signed by J. Caffieri (1698–1771) and the clock itself is the work of J. Martinet.

11. B. Guibal (1699–1757) and Jean Lamour (1698–1771). The Neptune Fountain, Place Stanislas, Nancy. The statues of this fountain by Guibal are in lead, the arches by Lamour in wrought iron. Designed by the architect Héré, the Place Stanislas, Nancy, is one of the most unusual examples of town planning of all times. This is largely due to Lamour's contribution. His black and gold palings give greater prominence to the surrounding buildings.

12. Gabriel de Saint-Aubin (1724–1780). *Party under the Orangetrees.* Black pencil and chalk on blue paper. *c.* 1750–1755. Ecole des Beaux Arts, Paris. This drawing is of particular interest because it illustrates a reception in the mansion of a Parisian nobleman. Note the intimate vibrating atmosphere which the sparkling light from the candelabra gives this sketch of almost Proustian poetical intensity, filling it with animation and life.

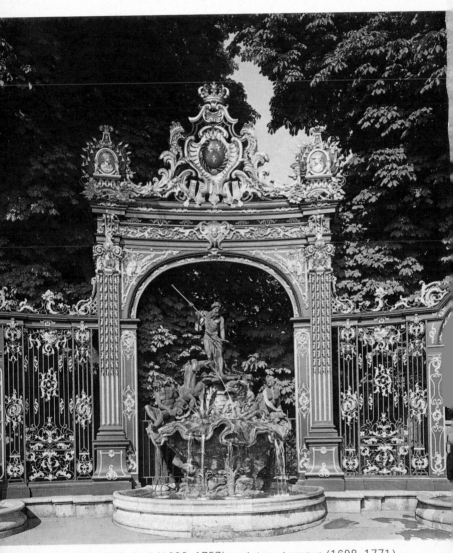

11. B. Guibal (1699–1757) and Jean Lamour (1698–1771).
The Neptune Fountain, Place Stanislas, Nancy.

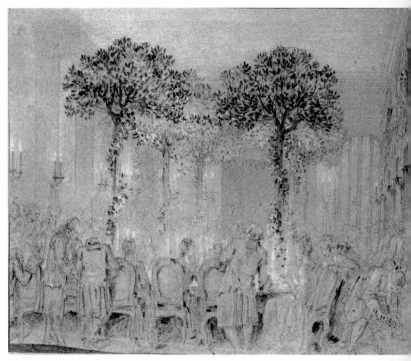

12. Gabriel de Saint-Aubin (1724–1780). *Party under the Orangetrees*. Black pencil and chalk on blue paper. *c.* 1750–1755. Ecole des Beaux Arts, Paris.

has been extended in English to mean the style in general.

At this point it may be useful to clarify what we mean by 'Louis XV' and 'Louis XVI'. Neither label corresponds to the dates of the two monarchs. The Louis XV style was already present in certain aspects of the Regency, and a cabinet-maker such as Charles Cressent, although considered typical of that period, could also be included under Louis XV. On the other hand, the Louis XVI style existed long before the death of Louis XV. In fact, after the discovery of Herculaneum and Pompeii, many Neo-classical motifs infiltrated into contemporary taste, and the protestations of the Comte de Caylus and of Cochin (the latter in 1756) against the excesses of Rococo slowly began to take effect. Even when Louis XV's reign had passed, Rococo furniture and fittings did not pass with it, so that the label 'Louis XV' does not necessarily imply that the object in question was made during his personal reign, 1722–1774. In the same way a painter like Fragonard, who belonged chronologically to the second half of the century, belonged also in certain respects to the art of the reign of the *'Bien-Aimé'*, whilst Madame du Barry, and even, latterly, Madame de Pompadour herself, patronised a style still not clearly defined but certainly more related to Neo-classicism than to the artistic trends which took the name of their royal lover.

During the reign of Louis XIV, France had already risen to a privileged position. Under Louis XV, despite all her political misfortunes she became the longed-for goal of every *bel esprit*, the Mecca of

culture whence fashion and taste radiated throughout Europe—a position she has maintained almost up to the present day. Due partly to family ties—the Bourbons reigned in Madrid, Naples and Parma—and partly to the 'Francomania' of the 18th century, fashion, literature, thought and the French language itself invaded every country. Curiously enough, the greatest resistance to the predominance of things French came from the Mediterranean countries. In Russia, Germany and Sweden, French became the language of all educated people. This fact is well illustrated in Tolstoy's novels for, when discussing serious questions, the characters did so perforce in French, because they did not know the words they needed in their native tongue. The same situation occurs in more modern novels, stories of a society nearer to us: Thomas Mann's *Buddenbrooks* for instance. In 18th-century Europe there was not a single aristocratic family which did not have French tutors and governesses, not one which did not speak, even *en famille*, the language which had become a sort of international Esperanto.

'At Focsani, Turkey and Russia
Decide in French the fate of Asia.'

That was Laharpe's quip, and what he said is very true. Leading European monarchs vied continually for the services of the most fashionable French artists, and acquired as many French works as they could. Frederick the Great possessed what was, perhaps, the finest collection of Watteaus in existence, besides having French sculptors to work for him and

being on most friendly terms with Voltaire. Catherine the Great kept up a busy correspondence with Diderot, and followed his advice when forming her enormous collection of works of art. In Portugal the Braganzas twice commissioned Parisian craftsmen to make a complete set of silver tableware and a number of gold articles. On returning to his native Naples after many years in Paris, Abate Galiani wrote letters full of tender nostalgia to his French friends asking them to send him some shirt material for himself and, as Harold Acton tells us in *The Bourbons of Naples*, some women's garters.

Italian painting in the 18th century had a considerable influence on French art. Rosalba Carriera, the famous pastel artist, visited Paris in 1720; and Giovanni Antonio Pellegrini came to paint a ceiling in the Hôtel de Toulouse, while French artists made frequent visits to Italy. Above all it was from Italy that the Neo-classical style began to make itself felt in France towards the middle of the century.

But Paris has always had the ability to absorb everything, no matter what the source, and to use it with a result that is, invariably, utterly French. This capacity for assimilation, this non-nationalism, at least in the field of art, brought to the capital the work of Alexandre Roslin, for example, the Swede who painted in an utterly French style.

Then there were the many artists, mostly Germans, the cabinet-makers who came to drink at the fountain, acquiring a lightness that was purely Parisian and in return imparting to France their consummate technical skill. Starting with Oeben, some of the greatest

cabinet-makers of the age were of foreign origin, and this applied to writers and thinkers as well— Helvétius, Grimm, and others. The presence of so many foreign artists and craftsmen resulted in an intra-European civilisation, French in essence but with an international touch which was to be absent for most of the next century.

By 1774, when Louis XV died, French society had been completely changed. The neat divisions established by his predecessor, *le Roi Soleil*, no longer obtained. Love of intimacy, of good conversation, of the things of the mind and of money had considerably toned down the sharp differences hitherto existing between classes.

This was evident not only in art but also in the way of life. Stools, once a sign of the social rank of the people who sat on them, no longer had this significance. Where previously 'one died in symmetry', as Madame de Maintenon said of *le Roi Soleil*, one now lived in pleasant comfort. In short, the modern world had been born.

PAINTING

In the realm of painting, the 18th century was dominated by one of the greatest European artists of all time, Antoine Watteau. Born in Valenciennes, he was instructed—educated is not the word—first by certain obscure painters, then by Gillot and Audran. But his real teachers were the minor Dutch masters whose pictures he had studied closely as a boy and,

above all, Rubens and the great Venetians whom he was able to admire in the Luxembourg Gallery and in the magnificent collection of his friend Pierre Crozat. The result of this complex schooling was a somewhat neurotic sensibility, an exquisitely misty and poetic refinement which the Goncourt brothers compare to Venice—perhaps because of the undercurrent of sadness concealed in his *fêtes galantes* and his pictures of lovers—while we can see the parallel between him and another 18th-century genius, Mozart.

Watteau evidently admired the great Venetian masters for he amused himself by drawing copies of, for instance, Titian (in the Lugt collection can be seen both Watteau's beautiful copy in red chalk and Titian's original pen-sketch). He succeeded in capturing the vague poetic atmosphere of a Giorgione albeit with a mysteriously erotic feeling that is entirely 18th-century.

Watteau was fond of contemporary Venetian artists as well, especially Rosalba Carriera, who painted his portrait during her triumphal journey to Paris in 1720. Here and there Watteau showed that he was influenced indirectly by Rubens, whose drawings

13. Antoine Watteau (1684–1721). Study of two men. Red chalk. *c.* 1716. Ecole des Beaux Arts, Paris. Watteau sketched this study for his painting *La Conversation,* formerly in the Heugel collection. The figures represented give this sketch a particular interest, for the man standing is Watteau himself, and the other is his friend Jean de Julienne, one of his first biographers.

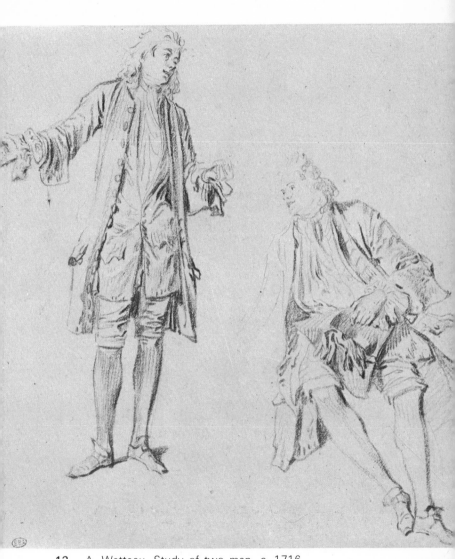

13. A. Watteau. Study of two men. *c*. 1716.

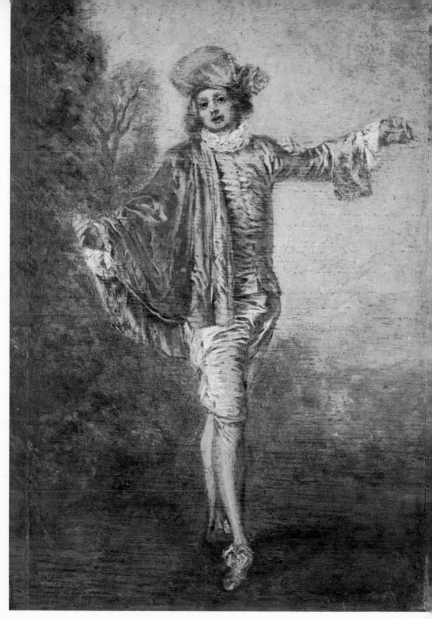

14. A. Watteau. *L'Indifférent. c.* 1716.

14. Antoine Watteau (1684–1721). *L'Indifférent*. *c*. 1716. Louvre, Paris. This 'Messenger of mother-of-pearl, this herald of the dawn, half fawn, half bird', as Paul Claudel described it, is one of the most famous works of the 18th century. It once formed part of the Marquis de Marigny's celebrated collection.

15. Antoine Watteau (1684–1721). *Fête Champêtre*. *c*. 1717–1718. Dresden Art Gallery. 'The great poet of the 18th century is Watteau . . . The grace of Watteau is grace. It is that something which gives a woman charm, and coquetterie, a beauty that transcends physical beauty. It is that subtle essence which seems to be the smile of the line, the soul of the form, the spiritual physiognomy of matter' (E. and J. de Goncourt).

16. Jean Baptiste Chardin (1699–1779). *La Brioche*. 1763. Louvre, Paris. Besides the exquisite quality of every brush-stroke, what is remarkable in Chardin is his love of modest 'private' scenes. This isolates him from the more worldly and more lyrical current of his times and brings him nearer to the 17th-century 'painters of reality', or even to certain masters of Impressionism.

15. Antoine Watteau (1684–1721). *Fête Champêtre. c.* 1717–1718. Dresden Art Gallery.

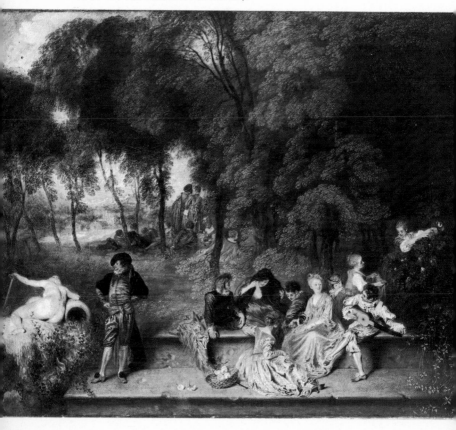

16. Jean Baptiste Chardin (1699–1779). *La Brioche*. 1763. Louvre, Paris.

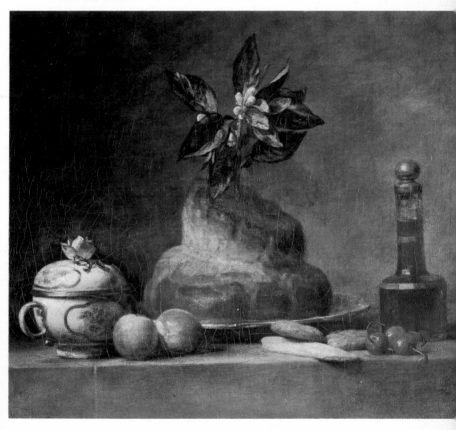

he often copied. He also possessed a picture by Rubens and spoke of it with veneration in a letter to his friend, Jean Julienne.

To cold eyes or too rational a mind like that of the great promoter of Neo-classicism, the Comte de Caylus, Watteau's paintings may seem disordered, lacking in action, confused, of imperfect execution or even superficial. But, except for Giorgione, no other artist has ever been able to capture so enchantingly the magic effect of golden light filtering through the trees. No other artist has ever succeeded in rendering that transparent, radiant, intimate haze which bathes marble statues, gives sparkle to the silks and laces of young girls stretched out upon the damp grass, lends flight to the wings of the cupids on the ship setting out, sails a-billow, from Cythera, the Island of Love. As Roberto Longhi aptly said: 'Watteau's art might seem superficial if it were to be exhibited in the Brancacci chapel alongside the Masaccio frescoes; but when a man extracts a fleeting quintessence from some flimsy costume or from some frivolous appearance, he can do so only because he observes and follows such things in an exquisitely poetic and seriously meditated way. Just as forceful an imagination and just as much moral strength is needed to convey lightness as to express energy.' Restless in spirit and a wanderer, Watteau had something in common with Primaticcio too and with those ill-fated poets of the last century, Verlaine and Mallarmé. According to his contemporaries, it was his unbridled restlessness that made him move from home to home. But this did not prevent his being a very keen observer, as he

showed in his famous *Enseigne de Gersaint* (Gersaint's shop sign) and in many other pictures drawn from life and inspired, as they often were, by the theatre, the barracks, even shells. In certain sketches, his observation is so acute, so carefully considered that it already has a suggestion of veiled psychology, and this with no weakening of the poetry. While he was still living, these drawings were in great demand and it is said that Watteau himself preferred them to his paintings. Technically they are of an astounding immediacy and strength—'cannons beneath the flowers'. Few artists have achieved similar vivacity using red chalk or *trois crayons*. And words can hardly describe the trembling, sensitive faces faintly melancholic under their powder and scent or the hands brought to life with four strokes of the pencil. 'Hands that think' is what the Goncourts said of them.

The work of Watteau was carried on by Jean Baptiste Pater and Nicolas Lancret, but they added little or nothing to it. At his best in his illustrations for Scarron's *Roman Comique,* for example, now in Berlin, Pater came nearer to Hogarth's work but without his biting English irony. Lancret watered down Watteau's poetical substance into a pleasing decorativeness, superficial and harmless, but always of fine pictorial content.

Watteau's true disciple was François Boucher who learned as a young man by engraving the master's drawings. Gifted with incredible facility—he himself said that he had produced about a thousand paintings and ten times that number of drawings—his capacity for work was miraculous—ten hours daily at the

easel. He seemed to paint to amuse himself, to pass the time. In a certain sense, he embodied the spirit of the age better than Watteau, the 'timeless' artist, and he gained from it all the honours and all the advantages: member of the Academy of Painting, where he was also teacher, rector and director; superintendent of the factory at Beauvais, then of Gobelins; and First Painter to the King. There was scarcely any branch of art that he did not dabble in: engravings, prints for books, designs for porcelain, fans, carriage-doors, ostrich eggs, dolls as well, and scenery for the opera house. In fact by disposition he was passionately active but he concealed this beneath the borrowed plumes of sloth and sensuality.

As a young man, Boucher went to Italy where he had time to study Tiepolo. There too he must have been able to see some of Domenichino's works, such as *Diana Hunting,* in the Galleria Borghese. In substance, however, Boucher always remained the quintessence of French taste. His lively enchanting paintings exude a *joie de vivre* that is really infectious, a voluptuousness that provokes and captures the onlooker. The Encyclopedist, Diderot, maintained that Boucher's imagination was that of a man who frittered away his time in the company of low harlots. But Diderot was rather a sour moralist, a man who patronised 'edifying' art, in brief something of a prude. Undoubtedly, Boucher's paintings have a touch of the lascivious. Where Watteau would only allude to, imply, a sensation poetically, Boucher expressed it in full; where before desire lurked in the shadows, enthusiasm now reigned, wilful and some-

what unbridled. This may seem rather amoral, but it is no more. Frankness and innocence cannot be called pornography. What can one imagine more chastely insinuating, more playfully naïve than Boucher's trim little bare-foot shepherds playing their flutes or eating grapes beside the spring, or his naked girls among the flowers—all strawberries and cream? In those mythological inventions 'adored' by his patron, Madame de Pompadour, Boucher's gods were all too human; here making love under canopies of satin held aloft by cheeky cupids and milk-white doves, there the sun rising all ablaze over ruby-eyed dolphins, a duchess or two playing the water-nymph, triton blowing his rosy shell and a sea of cotton clouds!

Indeed Boucher left no field of art untried. No one can forget those typical little scenes of his, *La collation, La modiste*—vignettes of daily life, like the work of a Parisian Longhi—or his landscapes, all porcelain skies and trees like silver wings in a theatre. His occasional *chinoiseries* were pictures which, with presumptuous candour, he painted indifferent to whether they were destined for the gallery of one of La Pompadour's châteaux or the palace of the Emperor of China! With a stroke of his soft lively brush and the guidance of his inexhaustible innate ability everything became *chic*. Not always elegant, perhaps, and as Diderot complained, at times a little vulgar. But a vulgarity clad in lace and rouge and scattered with diamonds and rubies, like those that Boucher had in his studio, is deliciously appealing as long as it has Boucher's spontaneity.

One could not imagine an artist less like Boucher than Chardin. All the proud finery and sophisticated *décor* of the former assumes a humble, restrained and restful demeanour. The Goncourts aptly said of Chardin that there was nothing in nature which he did not respect. Chardin had the power of investing with a particular dignity any theme he handled, be it poverty or the middle classes. He moves one far from Boucher's world all dressed for the ball, the very society of which he himself was a member! In Chardin's world, one has, for example, the little gallery of children's portraits, children surprised at play, some holding a tennis-racquet, others making castles out of cards, some intent on sharpening pencils and others at little tables immersed in their books. These portraits reveal a search for truth that seems to go beyond the action depicted. They give you the impression of looking at a film that stops, leaving the picture on the screen for an instant, and this held *ad infinitum* in total immobility is what gives them a feeling of reality.

Then there are all his good housewives returning home weary from their shopping, their vegetables wrapped in a cloth, or peeling potatoes, or treating wool. One takes water from the demi-john, one does the washing with the child beside her blowing bubbles —and the mothers feeding their babies! It is this aspect of Chardin's world which reveals his love of the little trivial things in life, which already has something of the 19th-century *bourgeoisie* but still has the grace of the 'Century of Enlightenment'.

As painters, Watteau saw light in melancholy

17. Francois Boucher (1703–1770). *Mademoiselle O'Murphy.* Alte Pinakothek, Munich.

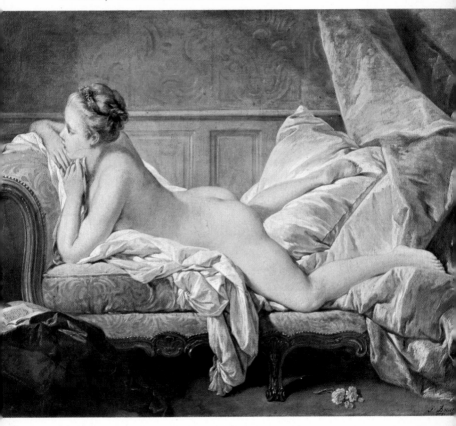

18. François Boucher (1703–1770). *Sleeping Diana.*

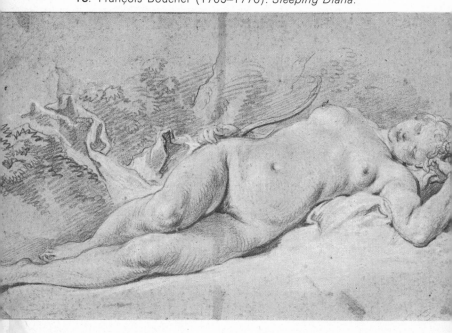

17. François Boucher (1703–1770). *Mademoiselle O'Murphy*. Alte Pinakothek, Munich. Here depicted languidly sprawling on a typical Louis XV day-bed, the model, Louise O'Murphy, was one of the King's many occasional favourites. She embodies well that type of feminine beauty which Boucher liked so much; pink, rounded, pleasing and appetising, as was his painting.

18. François Boucher (1703–1770). *Sleeping Diana*. Before 1735, as can be deduced from the way in which the artist signs his name. Red and white chalk on grey paper. Ecole des Beaux Arts, Paris. This is considered one of Boucher's finest drawings. A seductive example of the taste for mythology at that period, the picture also shows the triumph of Rococo in its most sensual vein.

19. Jean Baptiste Chardin (1699–1779). *The Kitchenmaid*. National Gallery, Washington. Here Chardin steps into the tradition of the Dutch school and of Le Nain, yet with a poetic and pictorial quality that belongs to his own times. 'There is nothing in nature which he does not respect,' wrote the Goncourts. But respect for human dignity was characteristic of the civilisation of the much vaunted 'Century of Enlightenment'.

20. Jean Marc Nattier (1685–1766). *La Marquise d'Aubin*. Musée Jacquemart-André, Paris. 'One would think that the chief pastime of these ladies was raising birds, especially those most difficult to approach, judging by the eagles to which they offer white wine from golden goblets' (Charles Nicholas Cochin).

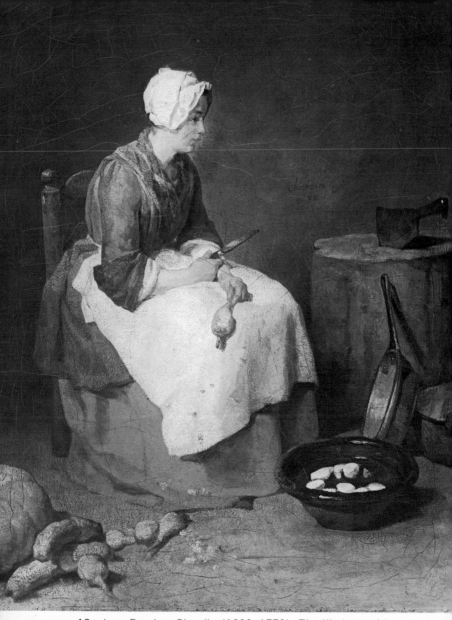

19. Jean Baptiste Chardin (1699–1779). *The Kitchenmaid*.
National Gallery, Washington.

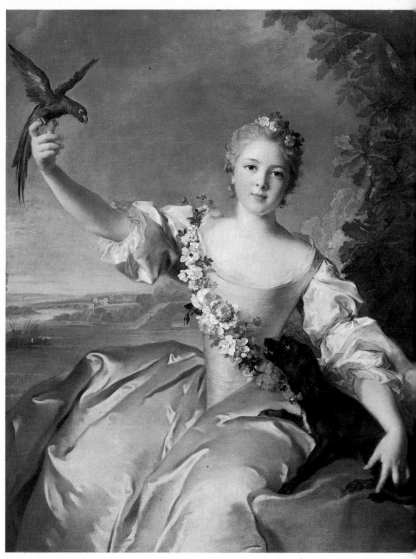

20. Jean Marc Nattier (1685–1766). *La Marquise d'Aubin.*
Musée Jacquemart-André, Paris.

glimpses, Boucher in joyful flashes, but Chardin's eyes revealed to him something that the Dutch had already noted, something that Manet was to see later on. Light, they noted, was all made up of colour, and each tone was broken up so that one has blue reflections in pink, and pink shadows in green, the whole gently wrapped in a silver veil, fluid and porous. Few other painters seemed to see light as Chardin did or used the ideas of the Impressionists before that word was invented.

Chardin's art reached its height in studies of what the English call 'still life', a better expression than the French *'nature morte'*. In such studies the peace and quiet of a Sunday fills the air, with the light filtering through the rough curtains and the greasy gloom of the kitchen, caressing the ancient objects set on the table—a pewter coffee-pot, a majolica soup bowl, greenish, almost silver, pears, a knife at an angle, and the green glass bottle for the wine which although not seen must be within ('the spirit of the wine sang in the bottles,' said Baudelaire). A wise critic has compared Chardin's still life studies to certain paintings by the Crespi who came from Bologna. They may evoke another painter from that city, Giorgio Morandi. Chardin's pictures show the same orderliness, the same meticulous cleanliness, physical severity becoming moral severity. It is all there in that handful of objects on a white cloth against that abstract background where the soft dim light slowly peters out.

Although a member of the Academy, Chardin used to hang his pictures in the least conspicuous

corners at exhibitions. As an old man with failing eyesight, with his usual modesty he followed the example of Rosalba and took up pastels. He has left us some unforgettable works in this new medium no less than in those to which he was accustomed, for instance his moving self-portrait. On his head he wears a sort of handkerchief tied with a blue ribbon, round his neck a cerise scarf, and his pince-nez are about to fall off, to reveal that timid, rather withdrawn but none the less penetrating expression.

'Every human being has had to bear to a greater or lesser extent the burdens proper to his status. These leave their mark—in a more or less pronounced way. The important thing is, first of all, to know how to seize upon this so that when you have to paint a king, a general, a minister, a magistrate, a priest, a philosopher, a porter, these people reflect their position as much as possible.' According to Diderot's account of the 1769 Salon, these were the words of Maurice Quentin de La Tour, the most successful French portrait painter in the first half of the 18th century, and a man who carried out his theories in practice. His curiosity about the human mind, his constant probing into the soul and his acuteness have left us a real gallery of portraits, excellent likenesses of the leading figures of his day, shown, in the main, as genuine human beings, unlike Nattier's somewhat pompous rhetoric depicting the French aristocracy as mythological characters ready for a masked ball. Even in his most official portraits La Tour always manages to put us in contact with an individual. In his painting of Madame de Pompadour, for example

(Plate 3), he shows us the Marquise, not deliciously idealised as Boucher would have presented her, not decked out as Diana or Hebe as Nattier would have liked, but just as she sat in her boudoir, surrounded by her books, her drawings, with her slippers on, and looking at a music score. If this 'reality' seems a little affected it is part of the sophisticated, somewhat precious spirit of the age. In the 18th century an exquisite and intellectual Marquise could not be presented like one of Caravaggio's women of the people or with the sad and anguished look of a Francis Bacon character.

Although Diderot saw La Tour as a genius of technique, albeit somewhat mechanical, the numerous series of rough sketches made by the artist for his pictures show the liveliness and freshness of his skill, his complete non-conformity. A few strokes of a lead pencil highlighted with pastel and chalk were enough to capture an expression giving the different faces a vitality which was astounding. What was calm and still in Chardin is here full of liveliness and movement, held only for an instant. 'All those eyes seem to be watching as though one has interrupted the 18th century talking in this great room where every mouth has just fallen silent.' So wrote the Goncourts of the La Tour Room in the museum at St Quentin.

La Tour sold his work for its weight in gold, and was considered eccentric—irascible and cynical—almost a Voltaire in miniature, judging by the clever yet cutting answers he gave everyone, even the King. La Tour finished up as an old man almost crazy, besotted perhaps by the cult of a philosophy only

half digested which led him to a curious admiration of nature and of man, already savouring of Romanticism. A protégé of the royal family, however, he had a success that overshadowed the no less important talents of other contemporary artists—Perronneau, for example, who ceded nothing to La Tour as a wit, nor as a painter, as can be seen in the beautiful portrait in oils (La Tour used pastels only) now in the U.S.S.R.

In the France of Louis XV there were so many more painters that it is unfortunately impossible to list them all. But it is difficult not to mention Gabriel de Saint-Aubin's exquisite evocations in a key which is already almost Proustian. Nor can we entirely ignore the best portraits by Louis Tocqué and the van Loo family, some work of the great animal painters Desportes and Oudry, the most graceful of Lepicié's little scenes and the *turqueries* of Liotard.

SCULPTURE

Thanks to Coysevox and Robert Le Lorrain, the sculptors of Louis XV's time had a considerable heritage behind them. Coysevox's beautiful group, *The Duchess of Burgundy as Diana,* served as a model for many of his successors, even for Houdon, and Robert Le Lorrain's bas-relief *Horses of the Sun* in the Hôtel de Rohan was a truly poetic source of inspiration. The presence of Bernini was also felt everywhere, not merely because during his short trip to France the great Italian had made a bust of *le Roi Soleil*

which had an authoritative influence for all future sculptors; but the greatest influence of all was the constant study of his works in Rome by students of the French Academy, and these were the greater part of the French artists of the age, men such as Lemoyne, Bouchardon, Pigalle, Falconet, Coustou, the Slodtz family, and the French Adam brothers. Around 1740 many of them were to be found working on the Fountain of Neptune at Versailles where their lead statues, a little clumsy perhaps but highly decorative, stood out well against the green lawns and the leaping water.

As it happened this tendency towards the decorative was often the sculptor's worst enemy. Although the official court portraitist, J. B. Lemoyne, was an artist of undoubted talent, he was frequently banal, conventional, too scholastic, a parallel to Nattier in sculpture, one might say. On the whole his French contemporaries and Diderot in particular liked his portrait busts: 'they're flesh and blood,' the philosopher declared, but today they strike us as being somewhat empty and soulless.

The craze for mythology which, as we have seen, affected many painters, was not without its followers among the sculptors too. G. Coustou, for example, portrayed the King as Jove and the Queen as Juno. At least once, however, he reached an elegance and strength surpassing the purely decorative—in his Marly horses. Today they stand, one on each side, at the beginning of the Champs Elysées.

That Bernini's influence could be ill-assimilated is shown in contemporary funerary monuments,

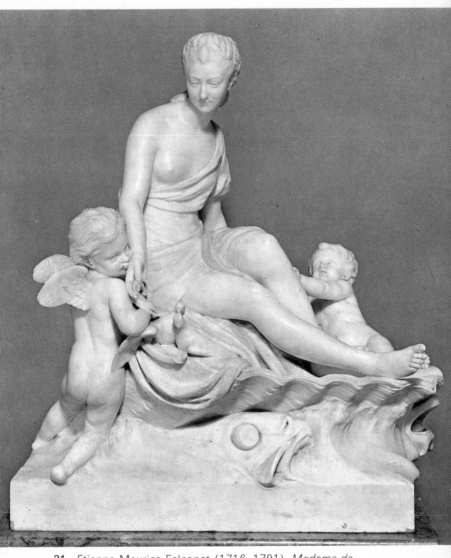

21. Etienne Maurice Falconet (1716–1791). *Madame de Pompadour as the Venus of the Doves*. Samuel H. Kress Collection, National Gallery, Washington.

22. Etienne Maurice Falconet (1716–1791). *Pygmalion and Galatea*. 1763. Sèvres biscuitware. Musée des Arts Décoratifs, Paris.

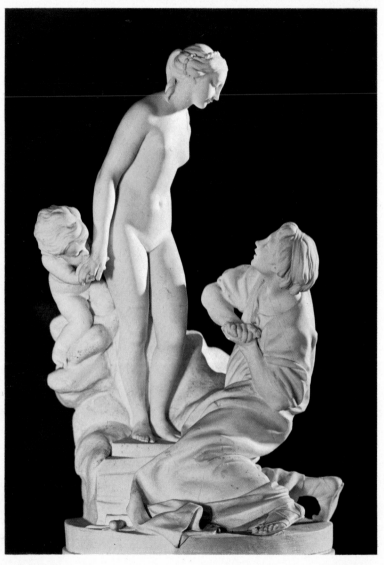

23. Jean Baptiste Pigalle (1714–1785). *Mercury lacing his Sandals*. 1744. Louvre, Paris.

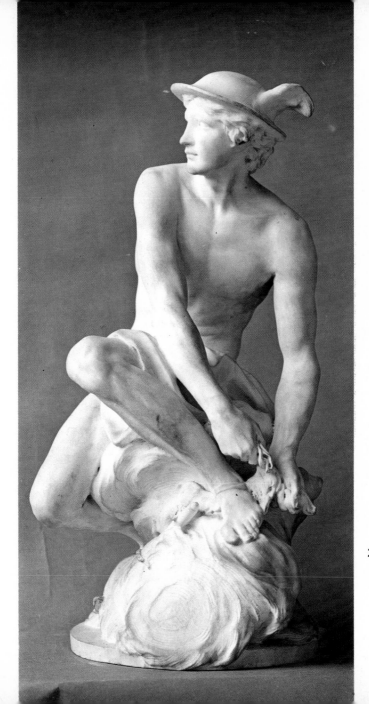

23

21. Etienne Maurice Falconet (1716–1791). *Madame de Pompadour as the Venus of the Doves*. Samuel H. Kress Collection, National Gallery, Washington. This is another example of the 18th-century passion for mythology. Similar in feeling to Boucher's paintings, but with a slight foretaste of Neo-classicism, this beautiful marble statue is one of the most representative works of the whole of the 18th century.

22. Etienne Maurice Falconet (1716–1791). *Pygmalion and Galatea*. 1763. Sèvres biscuitware. Musée des Arts Décoratifs, Paris. Falconet became director of the Sèvres factory in 1757 under the patronage of La Pompadour. He remained in that post until 1766, when he went to St Petersburg to build that masterpiece of sculpture, the monument to Peter the Great. Whilst at Sèvres, Falconet gave the industry a decisive personal touch which in some ways it still bears.

23. Jean Baptiste Pigalle (1714–1785). *Mercury lacing his Sandals*. 1744. Louvre, Paris. This early work by Pigalle is in the style or taste which is usually called Louis XV. Later, his work incorporated other values rising to loftier planes bordering on the religious.

24. Claude Michel Clodion (1738–1814). *La Gimblette*. Musée des Arts Décoratifs, Paris. This enchanting terracotta statuette by Clodion repeats the theme of a painting by Fragonard. Although, according to his dates, Clodion does not belong to the Louis XV period, he is included in this book because the greater part of his work represents the trend of art in the reign of the *Bien-Aimé*.

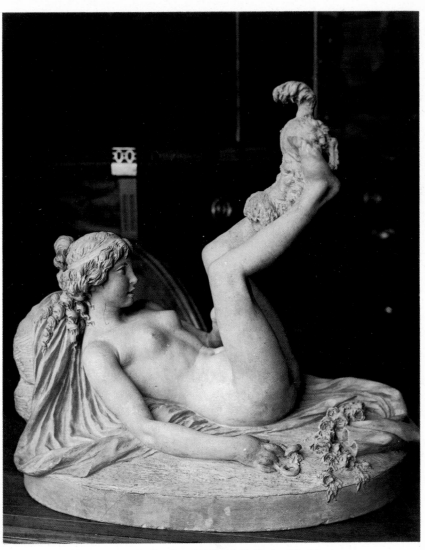

24. Claude Michel Clodion (1738–1814). *La Gimblette*.

those by the Slodtz in particular. Compared to the sublime work of the *maestro,* they were bombastic caricatures. In Pigalle's groups, however, there were one or two exceptions—on the tomb of the Maréchal de Saxe, for example, in the church of St Thomas at Strasbourg. Here, despite the ardour of certain figures, Pigalle obtained an overall effect of calm and great dignity which shows how well he could combine the passion of a Bernini statue with a lightly frosted elegance—a foretaste, perhaps, of the style at the end of the century. Though more rhetorical, too colourful, and too didactic in the tomb which he carved for the Comte d'Harcourt in Notre Dame, Paris, Pigalle was nevertheless a great artist. One can see this in his *Voltaire* which sparked so much criticism because of its heroic nudity, or in his *Diderot* with its sensuous, human face. Even in his early work, done twenty or thirty years previously when paying sacrifice to the stylish craze for mythology, he gave evidence of future greatness. For his entry into the Academy in 1744 he had submitted his *Mercury lacing his Sandals* (Plate 23), a figure showing nervous calm and contorted movement not devoid of elegance, perhaps even with a hint of sullen melancholy. In 1757 he carved his enchanting *Love and Friendship* for the Château de Bellevue with the figure of Madame de Pompadour alongside that of the King.

The same might be said but in a more frivolous key, more gracious, perhaps, but no less grand, of Etienne M. Falconet. He too was a protégé of Madame de Pompadour, and carved a number of decorative statues at her request besides portraying

her as the *Venus of the Doves* (Plate 21). In 1757, the year in which he finished his celebrated and delicious *Bather,* he found his true vocation, for, thanks to his patroness, he was appointed director of the porcelain factory at Sèvres. What he created there in unglazed porcelain, using partly his own ideas, partly Boucher's works, almost tempts one for a moment to think that, Pigalle's work apart, these graceful, fascinating figurines were the sincerest achievements of the day in sculpture. In 1766, at the invitation of Catherine II, Falconet went to St Petersburg and there made the fine equestrian statue of Peter the Great. The artist's real talent may have lain in producing decorative work for the drawing-room, but that war-horse above the rock and the imposing, forceful attitude of its rider are by no means lacking in regality.

By a strange stroke of fate, this statue is one of the few French royal monuments still *in situ*. Those which stood in Paris and other French cities were overthrown during the Revolution. To get an idea of what they looked like, we must study the small-scale copies which still exist. Historically, it is interesting to note that some of these copies were made in Vincennes porcelain—the Strauss collection has one—and they were certainly derived from the originals. Most of the latter have been destroyed, but we still have a fragment of Pigalle's monument to Louis XV at Reims, the figure of the *Citizen.* Carved in the artist's most restrained, most dignified, almost Neo-classical vein, this self-portrait is perhaps the most moving portrait of the century.

Unlike Falconet, Edmé Bouchardon enjoyed little

success during his life, at least as far as France was concerned. His nature led him to avoid the excesses of Rococo and remain faithful to a rather severe classicism of implicit moral undertones which, although displeasing to his contemporaries, was to become fashionable once more with Marie Antoinette (more for its classical aspect than for its ethical content). She chose as an adornment for her rotunda at the Trianon in 1778 a statue which Bouchardon had made forty years previously for the Salon d'Hercule at Versailles (not liking the statue, Louis XV had relegated it elsewhere). As a young man, Bouchardon had lived nine years in Rome and must have made a considerable name for himself there, for in 1731 Pope Clement XII commissioned him to do his portrait. It is because of this classicism that many people consider Bouchardon a bridge between the Louis XIV style and that of Louis XVI, for he almost completely ignored the tastes and tendencies of his contemporaries. Last but not least, mention should be made of Clodion (born 1738). His unbridled voluptuousness, his exaltation, his innate verve are qualities that bring him into line with Boucher and the young Fragonard. These are evident in the enchanting *La Gimblette* (Plate 24), illustrating, so one historian maintains, a game invented by Madame Du Barry.

ARCHITECTURE

We have already said that architecture was the art form least affected by Rococo. In fact, French archi-

tects of the Louis XV period seem to have had great respect for what had been created in the past, and did not hesitate to draw largely on what had been done in the previous reign. According to some critics, architecture was a bridge between the artistic trends of the time of Louis XIV and those of the late 18th century. Nevertheless, we must admit that the Louis XV style left its mark even on architecture—not so much in the general aspect of a building as in its detail—more grace, more femininity—in its lightness, its lack of archaeological fussiness, its *je ne sais quoi* of nobility which, without lapsing into frivolity, is never overburdened.

At the beginning of the reign of Louis XV architects abandoned the use of brick for façades and used fine grey or yellowish stone instead. To accentuate the stonework they lowered the tall grey-slated roofs with their gilded lead decoration. Although official buildings still breathed of the Sun King, interiors were now arranged more logically and, most important, with an eye to comfort. In the event this meant that architects became interior decorators. At Versailles the only large-scale undertaking was the completion of the Salon d'Hercule, but the various apartments were continually rearranged; hardly a day passed without Gabriel, the King's architect, inventing small rooms which were now preferred to the solemn 17th-century salons.

This desire for more intimacy affected plans for new mansions and châteaux. In city dwellings a courtyard would be enclosed by a mock façade which both separated the house from the street and screened

it from the gaze of passers-by. As a rule, the principal façade was the inside one which gave on to the garden and was adorned with a semicircular projection corresponding to the main salon. The same idea was adopted in suburban buildings too, although there architects made full use of the natural setting. Thus in the Château de Bellevue statues and arbours were scattered in the wood.

The most important example of religious architecture was the cathedral at Versailles which Mansart de Sagonne started in 1743. At first sight it seems fairly classical in style, but on closer inspection the bell-towers have a floral character vaguely reminiscent of Borromini, while inside the decoration is restless in feeling. By and large the same thing could be said of the Church of St Sulpice in Paris. Passing through the noble colonnade, part of Servandoni's façade, one steps into an exuberantly Rococo interior, where even the holy-water stoups—two enormous shells presented by the Venetian Republic to Francis I— rest on fantastic rock-work bases made by Pigalle.

Such stylistic ambivalence worried contemporary taste so little that architects did not hesitate to embellish the greater part of Gothic cathedral interiors with partitions of marble, wood or wrought iron. The fashion started in Notre Dame, Paris, with the work of Robert de Cotte.

Robert de Cotte was one of the most important architects of the age, although difficult to label because his work reflected the tastes of both the 17th and 18th centuries. To the 18th century, de Cotte brought his sense of majestic elegance (Hôtel de

Rohan, Strasbourg), his exuberant taste for decoration (the chapel at Versailles) and his brilliant innovations—if it really was he who invented the modern disposition of rooms and lowered fireplaces adorned with mirrors.

Having already mentioned Boffrand, the great interior decorator, and Heré, ingenious creator of the Place Stanislas at Nancy, we cannot overlook Jacques François Blondel. He is important chiefly for the influence he exercised on his pupils, among them Ledoux, who laid down the lines of Neo-classicism. There were the Gabriels, Jacques III and Jacques Ange, father and son, leading architects to the King, and relatives of Mansart, the Architect Royal, whose work, in a sense, they continued. The Place Royale, Bordeaux, a project on which father and son collaborated, does not lack grandeur, and 'grandeur' is the word to describe the Ecole Militaire, the first building undertaken by Jacques Ange on his own (1751). With its two orders of windows placed one above the other flanking a Greek tympanum supported by magnificent Corinthian columns, the impressive façade might lead one to suppose that for Jacques Ange contemporary taste did not count. Yet he was the designer of several interiors where the delicate air of the age rippled capriciously through the forms, like the pavilion in the French Garden at the Trianon.

Before leaving Jacques Ange one must examine the way in which he planned the square dedicated to Louis XV in Paris, today the Place de la Concorde. The King wanted it built near the Seine, but Jacques

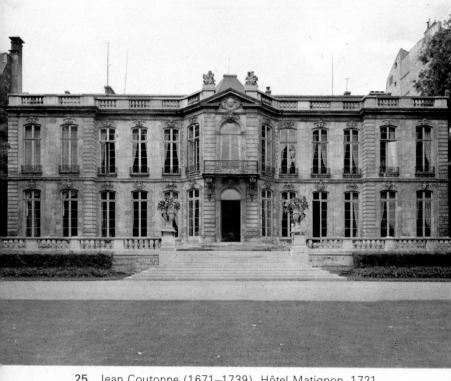

25. Jean Coutonne (1671–1739). Hôtel Matignon. 1721. Rue de Varenne, Paris.

26. Jean Lamour (1698–1771). The stairway, Hôtel de Ville, Nancy.

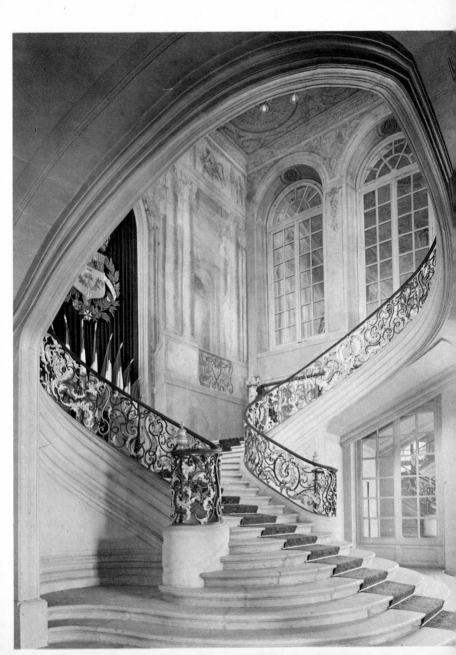

25. Jean Courtonne (1671–1739). Hôtel Matignon. 1721. Rue de Varenne, Paris. One of the best examples of a French 'stately home' of the first half of the 18th century. Note how well the projecting central bay sets off the whole building.

26. Jean Lamour (1698–1771). The stairway, Hôtel de Ville, Nancy. Situated in the Place Stanislas (1751–1755), the Hôtel de Ville was built by the architect Emmanuel Héré. Lamour collaborated with him for a long time on both the Place Stanislas and other projects undertaken by King Stanislas Leszczynski in this, the capital of Lorraine.

27. Inlaid roll-top desk. Private collection, Rome. Though far more sparing and simple in its execution, this desk has much of the more famous secrétaire in Versailles. The inlay here is in rosewood and purplewood, the dividing band and mounts in gilt bronze.

28. Cupboard-shaped secrétaire. Victoria and Albert Museum, London. This secrétaire of the same type as certain Renaissance and 17th-century cabinets, has a drop front concealing pigeon-holes and little drawers. The lower part masks other drawers and, sometimes, a safe. The inlay is in rosewood and purple-wood. The bronze mounts were gilded by the mercury process.

27. Inlaid roll-top desk.

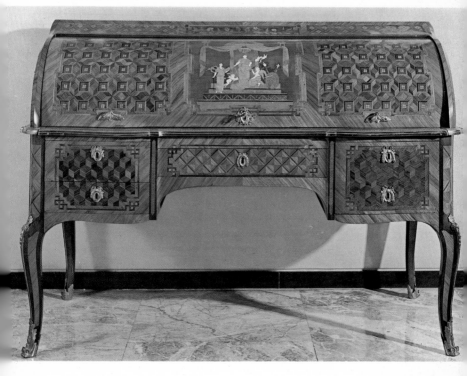

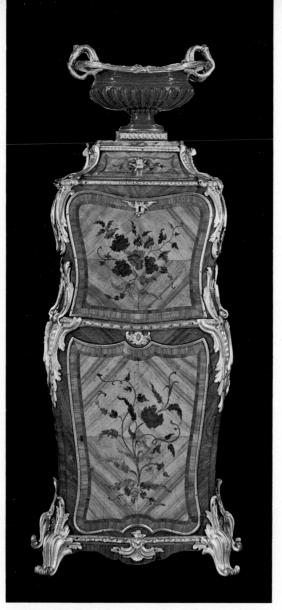

28. Cupboard-shaped secrétaire. Victoria and Albert
Museum, London.

Ange decided to build only his two famous porticoes with their classical columns opposite the river, leaving unmarred on the other two sides the green stretches of the gardens of the Tuileries and the Champs Elysées, where the Coustou horses now stand. By adopting this plan, Jacques Ange obtained a strikingly harmonious effect where nature and art meet, blending completely. The Petit Trianon and his other buildings, although erected in the reign of Louis XV, already belong to the school of Neo-classicism of which he had been an ardent precursor.

FURNITURE

It is no exaggeration to say that only in the 18th century did furniture acquire the look which was to characterise it during the whole of the following century and, generally speaking, up to the present day. The love of comfort and convenience, and the care with which rooms were fitted out by the carefree, rich and elegant society of Louis XV's France produced some of the most comfortable, even the most sensible, furniture ever invented. When examining this furniture, however, the reader should always visualise it in its original setting. What might at first seem an excess of bronze, lacquer or gold seems less so when surrounded with a carved panel (*boiserie*) of the same ornamental pattern, the softness of padded silk and brocade, and the tapestries and carpets frivolous or formal. But if such a piece of furniture with its gilt bronze mounts, a triumph

29. Louis Delanois (1731–1792). Small marquise à gondole.
Louvre, Paris.

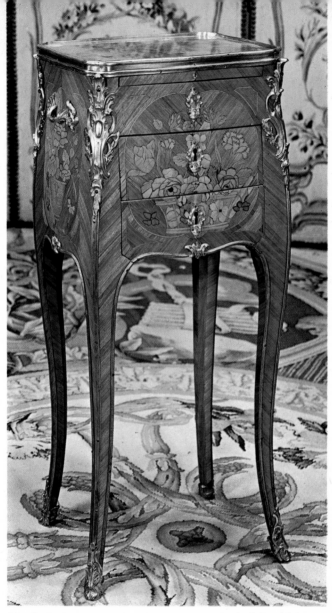

30. A. F. Delorme (active in the second half of the 18th century). Small writing-table. Louvre, Paris.

29. Louis Delanois (1731–1792). Small marquise à gondole. Louvre, Paris. Delanois was one of the most important *menuisiers* in the second half of the 18th century, especially at the time of transition between the Louis XV style and Neoclassicism. This is an example of his Louis XV phase. The marquise or causeuse was a small sofa for two (this one is a particularly small model). The wood is carved and gilded.

30. A. F. Delorme (active in the second half of the 18th century). Small writing-table. Louvre, Paris. The marquetry is particularly interesting with its baskets and vases of flowers, and as a whole the little table is one of Delorme's most successful creations. He specialised in this type of furniture which was very fashionable in the 18th century. Note the gilt bronze mounts and the handles on the sides for moving this exquisite piece, which dates from about 1755.

31. Charles Cressent (1685–1768). Commode. *c.* 1749 Louvre, Paris. *Ebéniste* to the Regent and the Orléans, Cressent had a long life, and part of his work is in Louis XV style. The bronze ornamentation was executed by Cressent himself despite the corporation rules against this. Note the two children playing with a monkey, reminiscent of the *singeries* of Gillot and of Audran, and of Watteau as a young man.

32. J. F. Leleu (1729–1807). Cupboard-shaped secrétaire à abattant. Musée des Arts Décoratifs, Paris. This Louis XV secrétaire with panels of oriental lacquer is a rarity for Leleu. His style was nearly always pure Louis XVI, so much so in fact that some connoisseurs think that his stamp on this piece means only that he restored it.

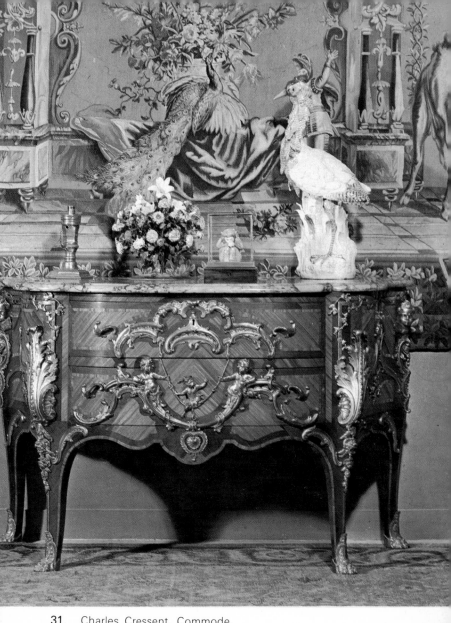

31. Charles Cressent. Commode.

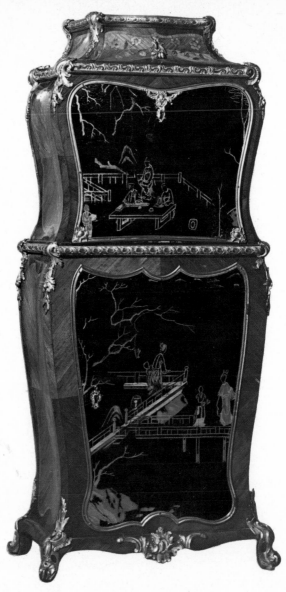

32. J. F. Leleu (1729–1807). Cupboard-shaped
secrétaire. Musée des Arts Décoratifs, Paris.

of harmonious if exaggerated curves, in rare woods of two, three or ten different kinds, is set in a modern apartment on a plain, moquette carpet beside an armchair covered in plain velvet, it makes a strange impression. For this reason furniture, more than any other work of art, should be seen in the setting for which it was made. And if one does not have access to the proper setting, then one must imagine it.

We have already seen that love of comfort and convenience was typical of the age of Louis XV. Let us take an item of furniture, the table for instance, and see what Frenchmen of those days could do with this basic idea. Up to then tables had tended to fall into categories such as those covered with a cloth and, for that very reason, of poor quality, or those which were placed against the wall (consoles). With the dawn of the new age, however, draped tables were laid bare, freed from their heavy covers, and it was now up to the *ébénistes,* the cabinet-makers, to give them a graceful, attractive appearance. One of the *ébénistes'* most successful models was the writing-table or bureau plat ('flat desk'). It was wide, usually rectangular, and the top was covered with velvet or morocco mounted with gilt bronze which twisted round and down the legs. Sometimes the bronze-work would be modelled with figurative motifs like the famous female heads inspired by the drawings of Watteau and called *espagnolettes*. Some beautiful examples of these were made by Charles Cressent who, despite his having worked for the Regent and the Orléans, may be regarded to some extent as a representative of the Louis XV style. More often

than not, the bureau plat had three drawers underneath. Quite early on, the *ébénistes* inserted sliding boards which could be pulled out and used as bookrests or for several people to write at the desk at once. The legs of the bureau plat were curved, and became more so towards the middle of the century, with more bronze mounts, especially round the top and feet.

The illustrations in this book show how gilt bronze, or ormolu, as it is known, accentuating the undulating lines of the bureau plat as a whole, served as a frame—a gilded, winding halo. J. F. Oeben, whose taste in decoration made him a precursor of the more restrained, more classical style of the late 18th century, preferred to limit the use of ormolu and, often using geometrical patterns, gave more importance to the inlay, of which he was a master. Other *ébénistes* inserted lacquered panels on the drawers like the magnificent bureau plat which Jacques Dubois made for the Duc de Choiseul (Plate 34).

The disadvantage of the bureau plat was that, except for the drawers, there was nowhere to keep papers and documents. Towards 1730 an entirely new type of writing-desk appeared—the secrétaire. The first model was the secrétaire à dos d'âne, à tombeau or en pente (called drop-front in English). It consisted of a table with a set of little drawers on top facing the writer, the lid came down to form a desk, supported on runners of wood or bronze. The advantage of this lid was that it could be easily shut. Secrétaires à dos d'âne were of all sizes. Those built for women were finished with particular care and, at

times, ornamented with lacquer or porcelain. A few were double and could be used on both sides, like the one made by the mysterious 'BvRB', recently identified as Bernard van Risen Burgh. According to Pierre Verlet, the expert in this field, this particular secrétaire, now in the Getty collection, was made for the twin daughters of Louis XV.

Shortly after the invention of the secrétaire à dos d'âne, a new model appeared, cupboard-shaped to stand against the wall. When shut, the lid was vertical; when open, it rested on the drawers or, more frequently, on two doors which, in some cases, concealed a safe. The upper part of this model was usually furnished with a shallow drawer, and topped with a sheet of marble. Of course, the *ébénistes* indulged their whims in the ornamentation of this type of secrétaire which, as time went on, adapted itself to changes of style.

Another type of secrétaire was the 'cylinder' or 'roll-top'. The first known example is one of the masterpieces of French furniture. It was designed by Oeben for Louis XV, and completed by Riesener, Oeben's pupil, who, after the latter's death in 1769, became his heir. As can be seen in the illustration (Plate 43), this extraordinary desk consists of a bureau plat surmounted by an upper part à dos d'âne which, instead of a drop front, has a lid that rolls up and disappears inside. The top is finished with a bronze gallery surmounted by a clock. Like all his bronzework, the candlesticks on the sides representing Apollo and Calliope are by Duplessis and Hervieu. The wooden surface is almost entirely

33. Nicolas Petit (1732–1791). Commode. Versailles.

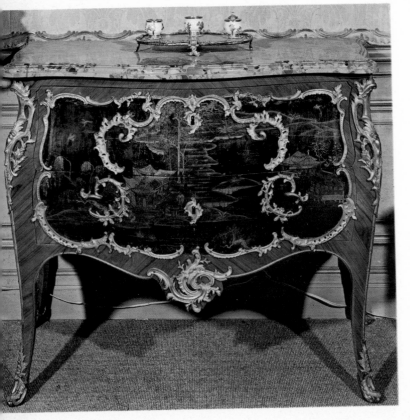

34. Jacques Dubois (*c*. 1693–1763). Bureau plat. Louvre, Paris.

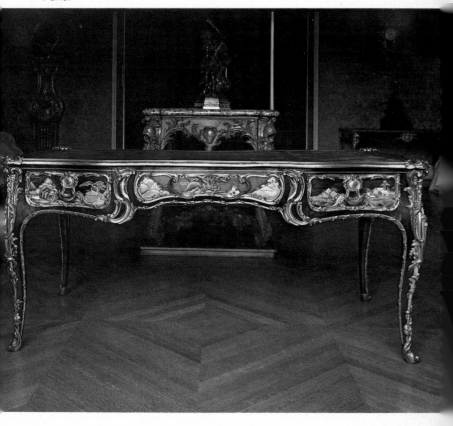

33. Nicolas Petit (1732–1791). Commode. Versailles. This piece is veneered in purplewood and has a panel of Chinese lacquer. The bronze mounts have a very marked Rococo character. As in many other of his creations after the early years of Louis XV's reign, the *ébéniste* ignored the division made by the drawers and treated them as one single surface.

34. Jacques Dubois (*c.* 1693–1763). Bureau plat. Louvre, Paris. It is only recently that Dubois's mark has been discovered on this magnificent desk, the property of the Duc de Choiseul, the King's minister. The fantastic beauty of the *chutes rocailles* make a splendid frame for the panels of oriental lacquer on the drawers. The proportions of the desk are perfectly balanced.

35. J. B. Tuart (second half of the 18th century). Commode. Private collection, Paris. The painted decoration of this piece was done in France with the famous vernis Martin, an imitation of oriental lacquer invented by the Martin brothers. J. B. Tuart senior was still alive in 1767; some beautiful lacquered and inlaid furniture bears his mark.

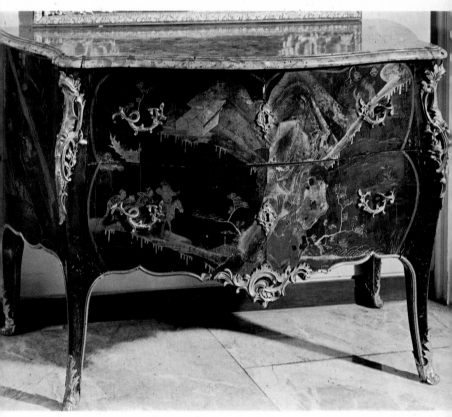

35. J. B. Tuart. Commode.

inlaid. These inlays (the symbols of royalty were altered during the Revolution by Riesener himself) follow a complex iconographical pattern by the Italian Jesuit, Padre Ripa. Louis XV followed the making of this desk with great interest. Besides being a masterpiece to look at, it was also outstanding mechanically. One turn of the key and the roll-top shot up, unlocking all the drawers inside simultaneously. Another turn, and everything closed automatically. By pressing an external control, one brought out from the sides two little drawers containing ink-wells which could be filled without the desk being opened.

Though never again constructed on such an elaborate scale, this type of secrétaire proved highly popular. The *ébénistes* had to copy it again and again with modifications dictated by changes in fashion, as one can see in the small one made by Oeben himself, now in the Musée Camondo.

The *ébénistes* of the Louis XV period showed more imagination and, at the same time, more practical sense in the infinite variety of small tables. Designed for a hundred and one purposes, these creations are fascinating for the rational character of their conception as much as for the excellence of their execution. Most popular of them all was the small writing-table, the miniature bureau plat; but a similar model might disguise a toilette in which case one raised the lid to find a mirror and the necessary implements. Some toilettes, however, were heart-shaped, with only three legs, drawers on each side and sometimes little doors below. The arrangement of the legs of this little table made it a very practical

shape to sit at and use as a desk, and it was frequently furnished with a drawer to serve as a writing-desk. On the other hand, many toilettes were nothing more than simple tables covered with muslin and, as such, cannot be considered true pieces of furniture.

The bonheur du jour was a writing-desk with a top part containing drawers and little doors. It enjoyed great popularity especially in the last decades of the century and, with some modifications, even under the Empire. One *ébéniste* of particular note in connection with the bonheur du jour was Topino.

Then there were all those stylish little pieces of furniture that proved so useful in the corner of a room, next to the bed, beside an armchair. There were square coffee-tables with lacquer, marble or porcelain tops; tables for emptying out one's pockets, small tables en chiffonière with a porcelain top like a tray and a shelf underneath lacquered to imitate the porcelain—the last word in refinement, as can be seen from Lacroix's enchanting work (Plate 37). Then there were tables en cas, a little higher than the others with a cupboard and hinged door; bedside-tables, tables de chevet, with two open shelves and handles at the sides for easy moving; ladies' work-tables, often with three round shelves with a tiny bronze railing like miniature basketwork round the top shelf. Next came the guéridon, a small table on tripod feet, usually to support a lamp or candelabra; and, perhaps much appreciated at intimate meals, the servante. The latter sometimes had a shelf that could be used as a tray and always contained tin receptacles for keeping the wine bottles cool.

There were several varieties of games-tables. Some were square, some round, some triangular, some covered with velvet, some with silk. Certain models had tops that could be folded over to cover the velvet or silk with a normal surface on which to write or eat. But where the century showed more ingenuity was in the tables à la Tronchin. By means of cleverly concealed handles, they could be raised to a suitable height for writing and drawing standing up. They were built for other uses too. Migeon's famous model contained six music-stands, one for each member of a sextet.

Up until the end of Louis XV's reign, Frenchmen had remained faithful to the time-honoured covered table when taking their meals. Now, under the influence of the English, they began to make proper dining-tables with polished tops.

The development of the chair was no less interesting than that of the table. Chairs and armchairs fall into two different categories. The first was the meublante or à la Reine, distinguished by its flat back. Meublantes were placed next to each other along the walls of a room. As a rule, their shape and look repeated the ornamental motives of the panels—the lambris or boiseries. They were seldom sat on, for their function was purely ornamental, and it is thus that we see them in an enchanting miniature on a snuffbox that belonged to the Duc de Choiseul, the King's minister, published by Francis Watson. The second type of chair and armchair was the courante or en cabriolet which had a curved back shaped for greater comfort. Courantes were placed in the

middle of a room where one could move them about and sit down to talk.

Apart from these two principal types, there were several others. The bergère, for example, a little bigger than an ordinary armchair, had a cushioned seat and padded sides and arms. If it also had a folding back and other gadgets making it still more comfortable, it was called a fauteuil de commodité and, like the one in which Voltaire died (Plate 47), could serve invalids. If the bergère was big enough for two people, it was a 'tête-à-tête' or 'confident' (today marquise is the more common term). A lower model in which one could sit at ease and warm oneself by the fire was called the chauffeuse while, again as the name indicates, a chaise longue was one which extended far enough for one to stretch one's legs out on. Usually, the chaise longue was flanked by a stool and another chair, smaller and often backless. The unit thus formed became a duchesse brisée, but if the three pieces were built as one, it was called simply a duchesse.

A voyeuse was an armchair especially designed for games. The top of the back was padded so that other people could lean on it and watch (see Plate 40, a picture of one of Tilliard's designs). The voyeuse could also be an armless chair, one where men sat astride facing the back and leaning their elbows on top. The women's model had a lower seat on which they knelt to rest their elbows like the men, yet another instance of the freedom and informality enjoyed by French society in the days of the *Bien-Aimé*.

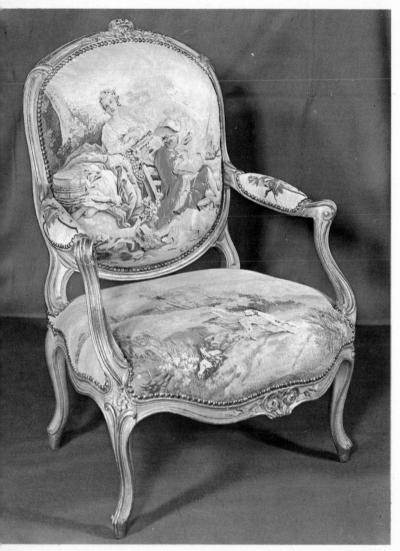

36. Louis Delanois (1731–1792). Armchair. Louvre, Paris.

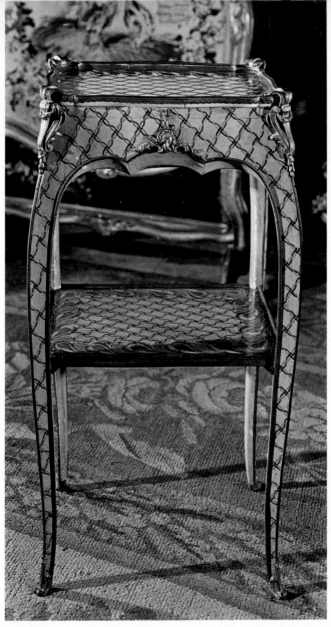

37. R. Lacroix (1728–1799). Table en chiffonnière. Musée
Nissim de Camondo. Paris.

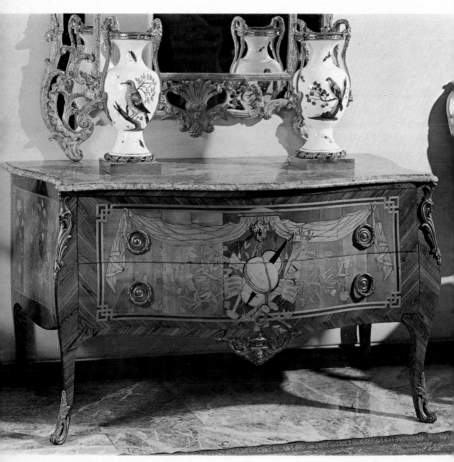

38. Transitional style commode.

36. Louis Delanois (1731–1792). Armchair. Louvre, Paris. This armchair by the *menuisier* Delanois, who also worked for Madame du Barry, is of the type called meublante. It has a straight back and stood against the wall—more for decoration than for use. The tapestry upholstery was woven at Beauvais from designs by François Boucher. This piece comes from the Château du Gatelier (Loire).

37. R. Lacroix (1728–1799). Table en chiffonnière. Musée Nissim de Camondo, Paris. In addition to the perfect balance and minute dimensions of this piece, the decoration of the lower shelf repeats exactly that of the one above. The upper shelf is of Sèvres porcelain, which has maintained its colour intact but the once white lacquer of the rest of the piece has yellowed with age.

38. Transitional style commode. Private collection, Paris. In this particular commode all the bronzework is Rococo except the handles which are Neo-classical in style. This may have been due to a replacement caused by the rapid change of fashion. Note the central trophy in inlay.

39. F. Reizell (died in 1788). Corner cabinet. Musée des Arts Décoratifs, Paris. This is one of the few pieces of furniture known to be by this *ébéniste,* who was of German origin and who lived and worked in Paris where he made many objects for the Prince de Condé. Reizell was particularly noted for his inlay-work which is delicate and imaginative.

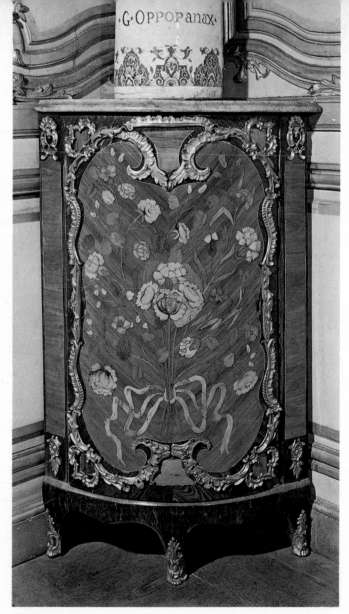

39. F. Reizell (died in 1788). Corner cabinet. Musée des Arts Décoratifs, Paris.

Those chairs used in the office must not be forgotten, the chaises de cabinet which were usually leather-covered. Then there were those on which one sat to make one's toilette which were more curved and with a lower back and had legs arranged in a diamond pattern. As for benches and stools, they too came in several kinds. So did the bidet and that other intimate structure euphemistically labelled the chaise d'affaires or chaise percée. Of this genre, some fine examples still exist, Madame de Pompadour's rosewood bidet, for instance, from her favourite residence, the Château de Bellevue.

Among the different sorts of divans or canapés, there were those with a step designed for billiard rooms; the à confident with two small armchairs fitting into the corners between the divan and the wall; the à corbeille or ottoman of well rounded form which was frequently placed in a mirrored alcove. The veilleuses had one wing higher than the other or sometimes only one wing. They were used in pairs, one on each side of the fireplace. A veilleuse of particular elegance is the one made by Jean Nadal in the Rijksmuseum, Amsterdam (Plate 49), where the legs are particularly well placed and which has a pleasing undulating shape.

To a certain extent beds continued in the tradition of the preceding century, for some of them, the so-called French beds, remained entirely covered with material. As time went on, however, and woodwork became more and more exposed to view, there were a whole list of colourful names—à l'anglaise, à l'italienne, à la turque, à la polonaise. These corres-

ponded to slight variations in the shape of the canopy or impériale which was sometimes bigger, sometimes smaller than the bed, and could be square or round, held up by columns or fixed to the wall. The base of the bed, the wooden part which was visible, resembled that of the divan.

Great importance was given to upholstery—especially in the type of furniture which the French call menuiserie—that is, neither veneered nor inlaid—in which the carved or sculpted wood is enriched with gilding, polychrome decoration and with upholstery especially designed for it. This could be silk (usually in a floral design, seldom plain), velvet, brocade, damask, leather or *petit-point* embroidery (even the daughters of the King did not disdain such handiwork, and there are several examples of it—already in the style called Louis XVI). Then of course there was upholstery in Savonnerie or Beauvais tapestry, like the armchair by Louis Delanois in the Louvre (Plate 36). This seems to have been created to frame the pastoral scene—with the princess disguised as a shepherdess—designed by François Boucher, who had been director of the factory at Beauvais.

Under the Regency a new piece of household furniture had made its appearance. This was the commode or, to give it its full name, derived from its era, the commode à la Régence. It was a rather heavy structure with short legs and either three large well divided drawers, or two large ones and two small, occupying almost the whole front. With the advent of the Louis XV style the commode lost one drawer but, by way of compensation, gained longer curved legs,

40. J. B. Tilliard (1685–1766). Voyeuse. Musée des Arts
Décoratifs, Paris.

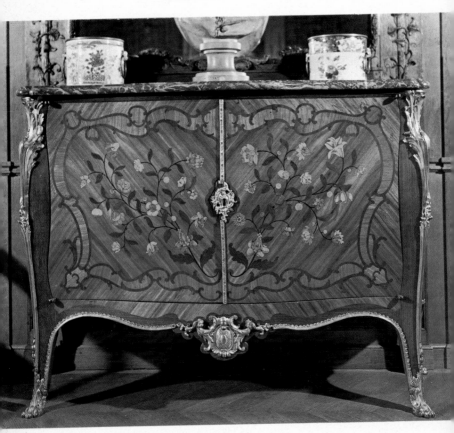

41. Pierre II Migeon. Commode.

40. J. B. Tilliard (1685–1766). Voyeuse. Musée des Arts Décoratifs, Paris. Because the sides are completely upholstered and the cushion is loose, this chair is a bergère, but it is also a voyeuse. The top of the back-rest is padded so that the spectator could follow the game in progress without distracting the player sitting in the chair, and would have his elbows comfortably supported.

41. Pierre II Migeon (1701–1758). Commode. Musée des Arts Décoratifs, Paris. This commode belongs to the type called à vantaux (with doors), which conceal drawers. The Migeons were known not only as *ébénistes* but also as *marchands*. They bought and sold furniture other than pieces of their own making.

42. C. Topino (second half of the 18th century). Bonheur du jour. Musée des Arts Décoratifs, Paris. The bonheur du jour was a type of furniture which became very popular towards the end of Louis XV's reign. It was a small table surmounted by an upper section containing little drawers and pigeon-holes. Topino's furniture is more appreciated for its elegance than its construction which is not always accurate. The vases of the inlay are a theme characteristic of Topino.

43. J. F. Oeben (*c.* 1720–1763) and J. H. Riesener (1734–1806). Roll-top secrétaire. Versailles. This is one of the most famous pieces of furniture in the world. It was made for Louis XV between 1760 and 1769 by two of the greatest *ébénistes* of all time—Oeben and Riesener. Remarkable for the extraordinary elegance of the inlay and the exceptional quality of its bronze mounts, the secrétaire is also a masterpiece of mechanism. During the Revolution, the symbols of royalty were removed by Riesener himself.

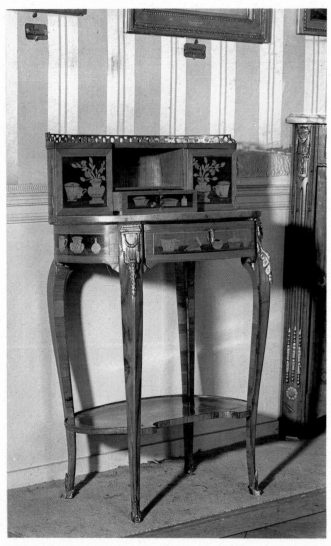

42. C. Topino (second half of the 18th century). Bonheur du jour. Musée des Arts Décoratifs, Paris.

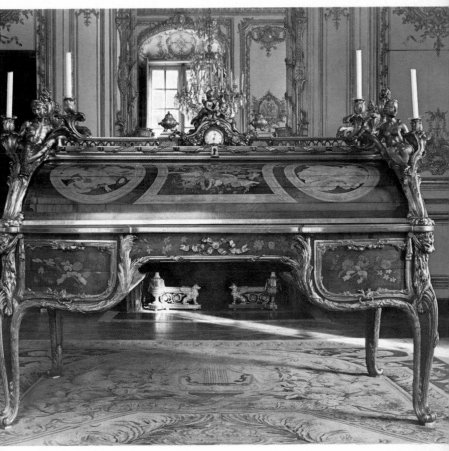

43. J. F. Oeben (*c.* 1720–1763) and J. H. Riesener (1734–
1806). Roll-top secrétaire, Versailles.

and the sides and edges became far more curvaceous. True, in the work which he did for Louis XIV, the great *ébéniste,* A. C. Boulle, may already have given some indication of this metamorphosis, but the model associated with his name did not become definitive until about 1730.

At first the transversal division of the drawers of the commode was clearly seen. Later on, it was ignored and the entire front treated as though it were one single surface. Such was the approach of Antoine Gaudreaux, one of the greatest *ébénistes* in the first half of the 18th century. Using a design drawn by the Slodtz brothers, he set to work in 1739 to build the superb commode for the King's bedroom at Versailles which is now in the Wallace Collection (Plate 44). With its magnificent marble top it has a very imposing appearance, like some *monstrum naturae* with its bulging sides and front, accentuated by Caffieri's wonderful bronze ornamentation—a riot of foliage, climbing like some abstract stylised creepers over its surface. It is most skilfully done, the central pattern serving to mask the division of the drawers, and the bronze protruding at certain points to the right and left to form handles.

In the transition period between the Louis XV style and the Louis XVI, neither of which, as we have already seen, corresponds necessarily to the dates of the two monarchs, the commode underwent further changes. While preserving curved legs, one new type, the commode à la grecque, had a straight body. There is one mentioned in an inventory of Madame de Pompadour's possessions taken after her death in

1764. That she should have acquired such a commode shows how up-to-date she always was, and how ready to encourage new ideas.

In some cases, particularly where two commodes graced the same room, doors were sometimes added to mask the drawers, as in the example made by Pierre Migeon (Plate 41) which has a particular elegance in the fine cartouche and the bunches of flowers which form the pattern of the inlay. Another variation was the extended commode with a corner-piece at each end, all part of the unit but open and usually with mirrors inside. Today such a unit will probably stand in the dining-room, but in the 18th century the mirrored shelves were used for displaying *objets d'art*.

Higher, narrower, more solid, and with much shorter legs, the bas d'armoire was a hybrid, a cross between a commode and an armoire. The latter was rare during this period, usually being classed as a wardrobe, an object, therefore, of little artistic interest.

A model of exceptional interest, and one lately restored to its original home at Versailles, is the commode with double doors made by Gaudreaux to house the medals of the reign of Louis XV (Plate 46). Count Salverte traced the design for it in the Bibliothèque Nationale, Paris. It was probably the work of the Slodtz brothers who had great influence on the taste of their day not only as sculptors and bronze-workers but as furniture designers too. Like all men of genius, however, Gaudreaux did not follow this design slavishly but made modifications wherever he felt them necessary. The commode rests squarely on

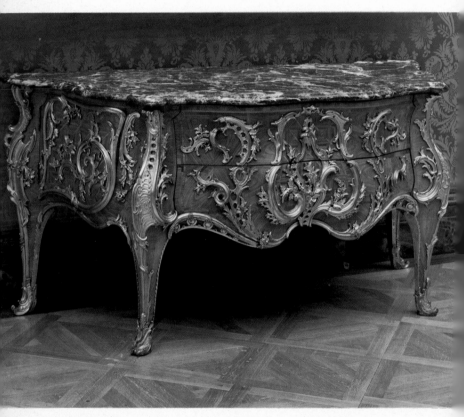

44. A. Gaudreaux (*c.* 1680–1751). Commode. Wallace Collection, London.

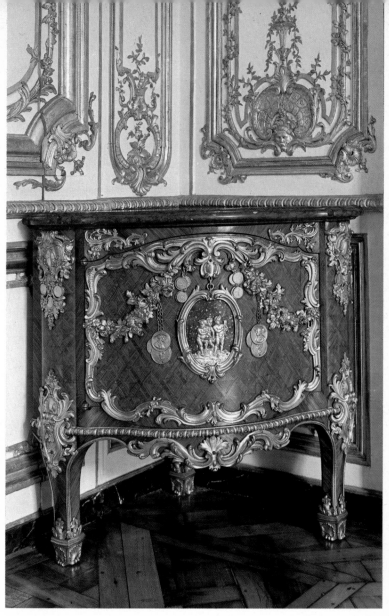

45. G. Joubert (1689–1775). Corner cabinet. Versailles.

44. A. Gaudreaux (*c*. 1680–1751). Commode. Wallace Collection, London. This commode was made for Louis XV's bedroom at Versailles in 1739. The preparatory design by the Slodtz brothers still exists but it was modified by Gaudreaux. The bronzes, of surprising quality, are one of the few rare works signed by J. Caffieri. Immediately after the death of Louis XV, his successor presented this commode to the Duc d'Aumont.

45. G. Joubert (1689–1775). Corner cabinet. Versailles. This encoignure was made in 1755 as a companion piece to the commode (Plate 46) which Gaudreaux had built for the Cabinet du Roi at Versailles. On the accession of Louis XVI, it was relegated with the commode to the Bibliothèque du Roi, Paris, and its place at Versailles was taken by furniture more in keeping with Neo-classical taste. The bronzework is magnificently chased.

46. A. Gaudreaux (*c*. 1680–1751). Commode. Versailles. Made by Gaudreaux in 1739 from drawings by the Slodtz brothers, who were also responsible for the bronzework, this commode first stood in the Cabinet du Roi at Versailles where it served as a medal case for the *Histoire métallique* of Louis XIV and Louis XV, both passionate collectors. Recently the commode has been restored to its original location.

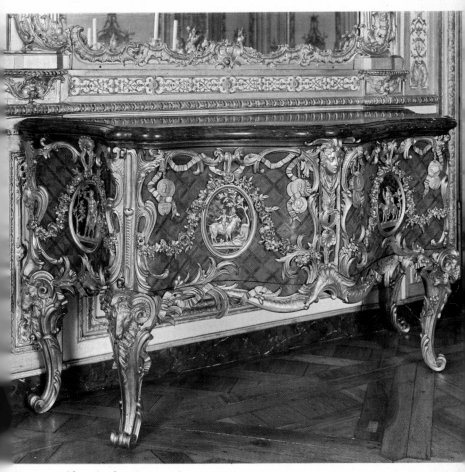

46. A. Gaudreaux. Commode.

47. F. Normand (active from about 1746). Fauteuil de
commodité. Musée Carnavalet, Paris.

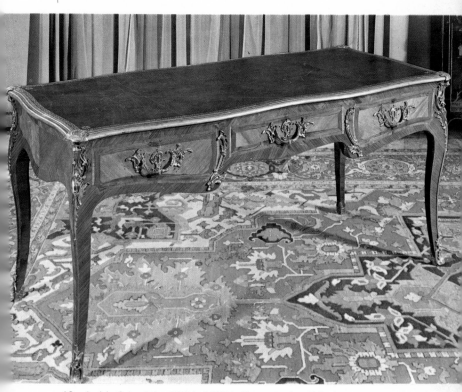

48. A. M. Criard (*c.* 1724–1771). Bureau plat. Private
collection, Paris.

47. F. Normand (active from about 1746). Fauteuil de
commodité. Musée Carnavalet, Paris. The fauteuil de com-
modité is simply a bergère with gadgets to make it more com-
fortable. It is also called a fauteuil de malade. The one shown in
this Plate is that in which Voltaire died.

48. A. M. Criard (*c*. 1724–1771). Bureau plat. Private
collection, Paris. This desk, still in Rococo taste, with the inlay
of rare foreign woods, is signed by Criard. A. M. Criard, son of
the famous Mathieu Criard or Criaerd (an *ébéniste* of Flemish
origin who always signed himself Criaerd), should not be
confused with his father, who seems to have made mainly
commodes.

49. Jean Nadel (active in the middle of the 18th century).
Day-bed. Rijksmuseum, Amsterdam. This particular type of
day-bed was called a veilleuse. As a rule, they were made in
pairs and stood one on each side of the fireplace. The day-bed
had only one wing so that one could stretch out comfortably.
The wood of the model in this illustration is carved and
lacquered.

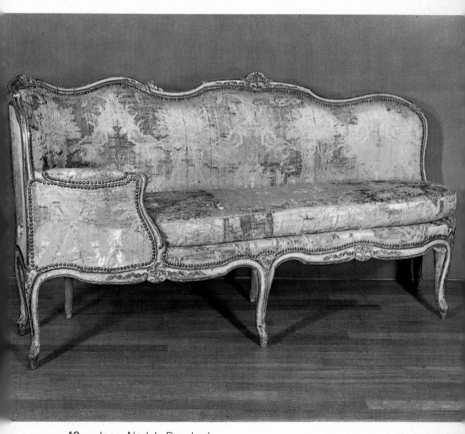

49. Jean Nadal. Day-bed.

four legs of solid bronze crowned with rams' heads, and from these the intricate bronze Rococo ornamentation weaves over the '*bois de violette*' in a graceful contrast of light and shade. Bronze ribbons supporting antique-style medallions branch out from a female mask above the lock. Beneath festoons of delicate floral garlands, medallions with classical figures on a mock lapis-lazuli background decorate the centre of the doors and the sides. In all it is an enchanting blend of the hedonistic art of the day with motifs taken from the art of antiquity, showing how the taste for the classical world was already beginning to make itself felt in 18th-century France, or rather, how it was never entirely absent from the story of Western art.

This magnificent medal-case stood in the Cabinet du Roi, but after the death of Gaudreaux Louis XV decided that he wanted two corner-pieces (*encoignures*) to go with it, and in 1755 he commissioned Gilles Joubert to make them. At a distance of sixteen years, Joubert was very successful in reproducing Gaudreaux's style (Plate 45), an instance of the difficulty of ensuring the date of an object or even naming its maker unless there are signatures and documents.

Corner-pieces which usually accompanied commodes might have one door, like the one by Joubert, and stand on two legs, or sometimes they might have double doors or stand on three legs like the one signed by Reizell in the Musée des Arts Décoratifs, Paris (Plate 39).

In olden days, corner-pieces were often surmounted by a number of shelves which were smaller

and smaller the higher they went. Very few examples of such items remain today, either because the shelves were built separately from the corner-pieces and could, therefore, be put to other uses, or because of a change in fashion. It is a shame, because built in the way they were, enriched with vases and other objects, they must have filled corners with elegance and made a room warmer and more intimate.

Unlike commodes, consoles in Louis XV's day followed the models fashionable during the previous reign and the Regency, adapting only to the lighter Rococo decoration. Usually they repeated the motifs on the commodes and chimneypieces of the rooms in which they stood, and even more frequently echoed the spirited lines of the *boiseries*.

Screens, which were quite common in Louis XV's day, consisted of richly carved frames usually gilded and fitted with rich tapestries or fine embroidery. The fact that they were meticulously finished back and front, both in the carving and in the material is an illustration of the extreme sophistication of the time. To my knowledge, there is only one example of such a screen in existence, in the Musée Camondo, Paris. The firescreens are similarly among the furniture in which the *rocaille* decoration (which gave rise to the name Rococo) was found with most success.

Thus the variety of furniture in France was greater perhaps during the reign of Louis XV than it had ever been before. No less vast, however, were the rigorous and well defined regulations which accompanied its manufacture. The *ébéniste* was limited to working his timber; he was bound by law to leave the

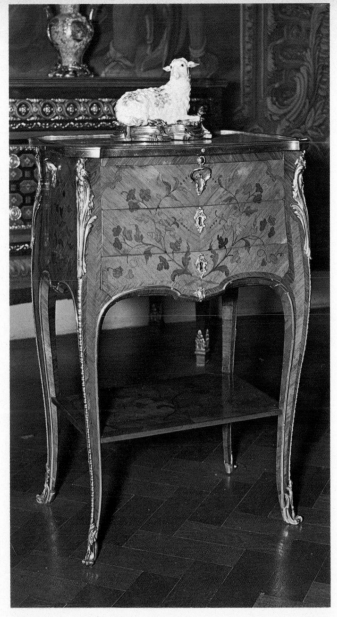

50. Writing-table with drawers. Victoria and Albert Museum, London.

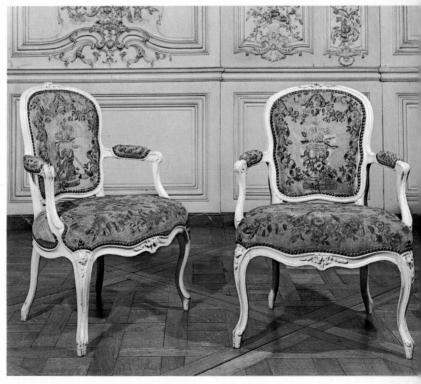

51. Louis Delanois (1731—1792). Two armchairs.
Bibliothèque de l'Arsenal, Paris.

50. Writing-table with drawers. Victoria and Albert Museum, London. This type of small desk, almost a miniature commode on its long slender legs, was most popular throughout the century. One of the drawers contained writing materials. Under the top was a sliding board that pulled out to serve as a desk. The inlay of the model in this illustration is of rosewood and kingwood.

51. Louis Delanois (1731–1792). Two armchairs. Bibliothèque de l'Arsenal, Paris. These armchairs were made for the Marquis de Paulny in about 1765. They are of en cabriolet or courant type, with curved backs. Courants were placed at random in the centre of a room for conversations, and were continually moved about, whereas the meublantes remained almost invariably where they had been arranged in the first place, along the wall.

52. J. Dubois (c. 1693–1763). Bureau plat. Louvre, Paris. With his signature so clearly in evidence, Migeon used to be thought the maker of this extraordinary desk, but recently the signature of Dubois was found near one of the legs. Being a merchant as well as an *ébéniste* Migeon did not wish the identity of the real maker to be known.

53. J. F. Oeben (c. 1720–1763). Secrétaire. Musée Nissim de Camondo, Paris. This is a smaller version of the famous roll-top secrétaire of Louis XV designed by Oeben who was perhaps the first to build this type of desk. Oeben was known not only as a master of inlay but also as an ingenious mechanic.

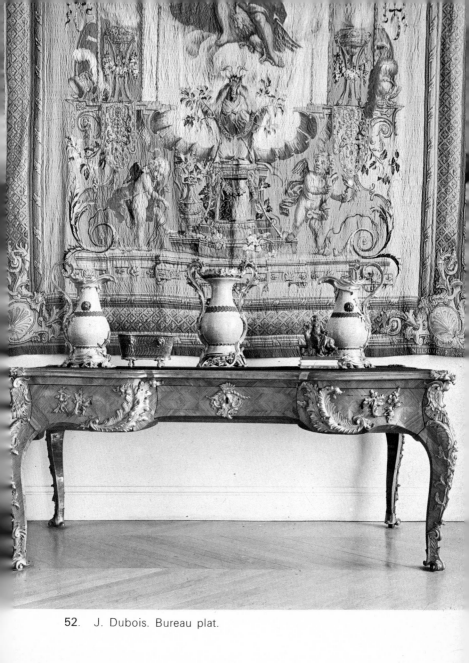

52. J. Dubois. Bureau plat.

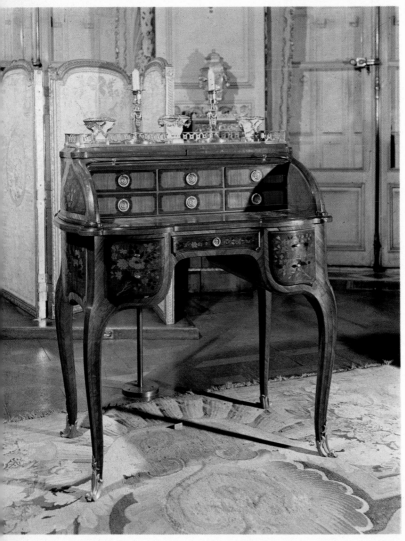

53. J. F. Oeben (*c.* 1720–1763). Secrétaire. Musée Nissim de Camondo, Paris.

finishing to the sculptors, the gilders and the bronze-workers. Cressent always wanted to do the bronze-work on the furniture that he made, and was taken to court more than once. All the craftsmen were jealous of Oeben who served the Crown and enjoyed special privileges.

In Paris, which is really the city that counts in the history of the Louis XV style, there was a corporation of *ébénistes* which from the middle of the century obliged its members to sign and stamp their work which would be counter-stamped by the corporation as a guarantee of quality. In cases where the corporation rejected a piece of work, its officers could forbid the *ébéniste* to sell. No wonder French furniture reached such a high level in the 18th century!

The same strictness applied to the turners, the gilders and the silversmiths as well. (There are some pieces of furniture still in existence with partly silvered, partly gilded decoration which made the colours stand out better, and was considered the last word in refinement. Such specimens are few in number, however, for the silvering tends to oxidise.) Equally subject to corporation rule were the upholsterers who not only dealt with the external upholstery but also lined the insides of drawers and boxes—not with just any piece of material but with silk or *moiré*.

The upholsterers' work was never done, for although the more wealthy houses could afford two complete sets of furniture, one for summer and another for the winter (some households even had two more—for spring and autumn!) it was a different

54. Vase of soft-paste porcelain, Sèvres. Musée des Arts
Décoratifs, Paris.

55. Soft-paste porcelain milk-jug and dish. Sèvres. Musée des Arts Décoratifs, Paris.

54. Vase of soft-paste porcelain, Sèvres. Musée des Arts Décoratifs, Paris. Rose-pink was produced at Sèvres for the first time in 1757, and it had a great success. The combination of rose-pink and green illustrated in this vase or pot-pourri did not appear until about 1759. Subsequently other colours were combined with rosé-pink as the base: in 1761 the factory tried out violet decoration on a rose-pink ground.

55. Soft-paste porcelain milk-jug and dish. Sèvres. Musée des Arts Décoratifs, Paris. The manufacture of French porcelain was endowed with the personal protection of Louis XV and Madame de Pompadour. Established at Sèvres in 1756, the factory became the absolute property of the King. Louis followed its affairs closely, and held an annual display of the best pieces in his private apartments at Versailles.

56. Saucer and cup with a butterfly-shaped handle in soft-paste porcelain. Vincennes. c. 1750. Louvre, Paris. The porcelain factory, which was under royal protection, was originally located at Vincennes, before being moved to Sèvres. The works produced during this early phase of the factory are rare. At Vincennes only soft-paste was used. Hard-paste came into use at Sèvres in about 1772.

57. Cup and saucer in soft-paste porcelain. Sèvres. c. 1758. Louvre, Paris. Another example which shows the quality of the pieces achieved by the craftsmen at Sèvres during the first years of production there. At that time, the factory employed many painters, each a specialist in a particular type of decoration.

56. Saucer and cup with a butterfly-shaped handle in soft-paste porcelain. Vincennes.

57. Cup and saucer in soft-paste porcelain. Sèvres. *c*. 1758.
Louvre, Paris.

story for the poorer families. Come spring, summer, autumn, winter, there were always chairs to be recovered, cushions changed and tapestries altered.

Even the great porcelain factories had a hand, supplying all sorts of attractive fittings and refinements for certain items of furniture, like Martin Carlin's little tables, to give but one example.

PORCELAIN

Admiration for Chinese porcelain was nothing new in Europe; as early as the 16th century, the Florentines had successfully attempted the manufacture of objects in this material. At Meissen, Saxony, in 1709 the Germans began to produce hard-paste porcelain, that is to say, using kaolin. This enterprise aroused such interest that every European court launched a hunt for it which, incidentally, gave rise to some curious and involved diplomatic incidents.

The use of soft-paste porcelain had been known in 17th-century France, and this was the material used at Chantilly in 1725 for the production of various objects in which the taste for *chinoiserie* predominated. But it was only in 1738 that the porcelain factory which was to become the most important in France and was to contest Germany's supremacy and win was founded at Vincennes. Shortly after, the King began to show a personal interest in the project and gave the factory the privilege of stamping its wares with two crossed 'L's.

Even in this early period the factory turned out

products of exceptional quality, not always decorated with *chinoiseries*. The saucer in Plate 56 shows how perfectly the floral pattern lends itself to the curves of the saucer, and twists up the cup so that the multi-coloured butterfly seems to poise trembling upon a bud. It is a most fragile graceful object, 'a nun of tableware', as Praz has called it.

In 1756 the factory was transferred to Sèvres, thanks to Madame de Pompadour. Already it employed three hundred and fifty workers, among them many specialised painters. Duplessis, the King's goldsmith, provided the models for the moulds, and the *Bien-Aimé* himself, now sole proprietor, organised an annual display in the royal apartments. The best pieces were put on show and sold, though not without a certain amount of persuasion, as la Pompadour was prompted to declare that a man who would not spend up to his last sou on porcelain was neither a good courtier nor a good Frenchman.

Soft-paste porcelain has a porous quality, and today is more appreciated than hard-paste porcelain not only because it is rare but also because it looks warmer and more pliable. Until 1769, however, when Sèvres adopted the use of kaolin, which gives more lustre and more hardness, both the French court and even amateurs regarded soft-paste as a compromise.

Even as early as this, however, the factory had the advantage of having the work of an artist of the calibre of Falconet. Using unglazed porcelain he created a whole world of enchanting white fairy-tale figures where one can recognise Boucher's enamoured shepherds and shepherdesses, and the nymphs and

58. Faience soup tureen. Strasbourg. *c*. 1753. Musée des Arts Décoratifs, Paris.

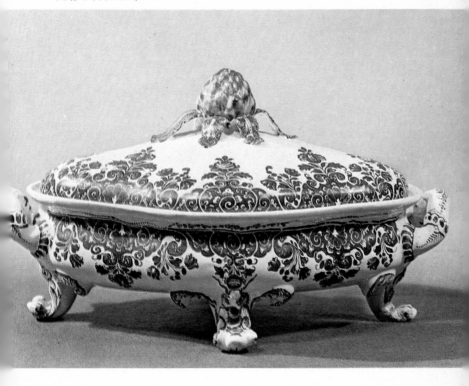

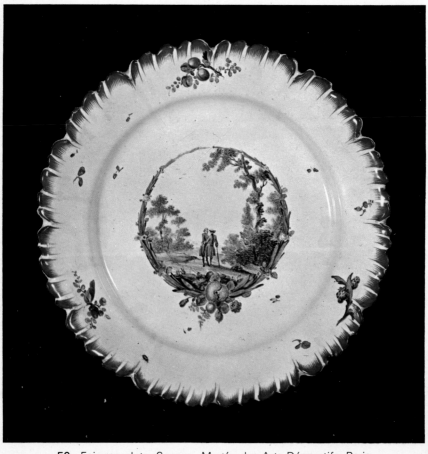

59. Faience plate. Sceaux. Musée des Arts Décoratifs, Paris.

the deities of the day forming little groups, often in languid embraces. They are the very incarnation of the rather precious character of the mid 18th century, but as minute decorative objects they have rarely had rivals which have more successfully embodied the taste of an age.

Among the most successful colours used at Sèvres —yellow, green and the various blues—the best known was *rose Pompadour*. This was produced for a few years only, from 1757 to 1761, as was the custom at the factory. This soft warm colouring is extremely pleasing but it has unfortunately suffered from the many gross imitations that have emerged during the last century. Really to appreciate its inimitable tint, it must be seen in the few authentic originals which still exist, such as that illustrated in Plate 54. As far as colours are concerned, it is this very *rose Pompadour* that typifies the *Bien-Aimé*'s whole reign.

Besides the factory at Sèvres, there was another at Mennecy and one at St Cloud. St Cloud's products were frequently white with designs in relief, always in imitation of the Chinese. The first man in France to produce objects using kaolin was Paul Hannong of Strasbourg. That was in 1751. But the royal factory grew so jealous that he had to flee and continue his work in Germany.

The principal *faience* factories were those at Rouen, Marseille, Strasbourg, Sceaux and Pont-aux-Choux. Interesting more for the beauty of its shape than anything else—the designers were the Germains and the Roettiers—the *faience* of Sceaux and Pont-aux-Choux is of a white ivory-coloured clay of

dense creaminess and great plasticity. Strasbourg *faience,* most elegant of all perhaps, is made from a very fine earth and has floral designs or *chinoiseries,* later copied by other factories. In the Veuve Perrin products especially, Marseille *faience* is of fairly high quality. The polychrome decorations are very carefully executed on a clear enamel background which is nearly always white but occasionally other colours. The representations of flowers, fish and landscapes show great imagination and intelligence in their adaptations to the various shapes. The Rouen products were the oldest of all, and the poly-chromatic colour schemes were faithfully maintained with particular predilection for cobalt blue, although yellow now became popular and red even more so despite its being a difficult colour technically. The factory tried to bring itself up-to-date by going in for Rococo and *chinoiseries,* but the results were a little heavy. Nor did they improve when an attempt was made to copy the light, floral designs of Strasbourg or Marseille.

TAPESTRY

The 18th century was not the century of tapestry. True, the three principal French factories, Gobelins, Beauvais and Aubusson, continued to produce magnificent and at times exceptional work, but now the fashion was to discard the use of loose wall tapestries and decorate rooms with *boiseries,* panels of inlaid or painted wood. And it has already been

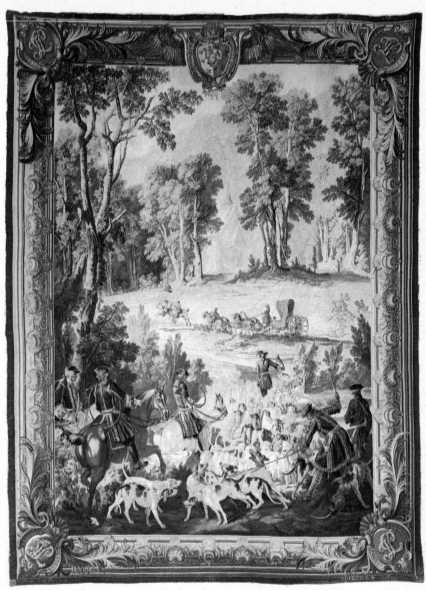

60. J. B. Oudry (1686–1755). *The Hunts of Louis XV*.
Gobèlins tapestry. 1743. Palazzo Pitti, Florence.

58. Faience soup tureen. Strasbourg. c. 1753. Musée des Arts Décoratifs, Paris. The Strasbourg factory was founded in 1721. In 1745 the director, Paul Hannong, began to experiment with hard-paste and finally succeeded in 1751, but the jealousy aroused at the Sèvres factory by his success caused him to abandon his project.

59. Faience plate. Sceaux. Musée des Arts Décoratifs, Paris. The factory at Sceaux was founded in 1748. Much of the decoration was inspired by that of Strasbourg which was enjoying great success in France at the time. The delicacy of the floral design is particularly remarkable on the plate in this illustration, as is the beautiful frieze that accentuates the *rocaille* border.

60. J. B. Oudry (1686–1755). *The Hunts of Louis XV*. Gobelins tapestry. 1743. Palazzo Pitti, Florence. Oudry became director of the Gobelins factory in 1733, and enforced the strict rule that weavers should follow the cartoons exactly. Among his best work in the factory were the cartoons for *The Hunts of Louis XV*, which he drew between 1739 and 1745.

61. J. B. Oudry (1686–1755). *The Hunts of Louis XV*. Gobelins tapestry. Palazzo Pitti, Florence. Another of the series, *The Hunts of Louis XV*, made from cartoons by J. B. Oudry. This particular piece of Gobelins tapestry is also among those preserved in the Palazzo Pitti, Florence. Having always been protected from the sun, they remain fresh as new, and are considered the best of the series.

62. *Hunters at Rest*. Aubusson tapestry. Mid 18th century. Petit Palais, Paris. Unlike other tapestry factories, Aubusson had only the nominal protection of the King. Its products may have been less refined than those of the royal factories, but they had greater freedom of design and a fresher and more spontaneous range of colours.

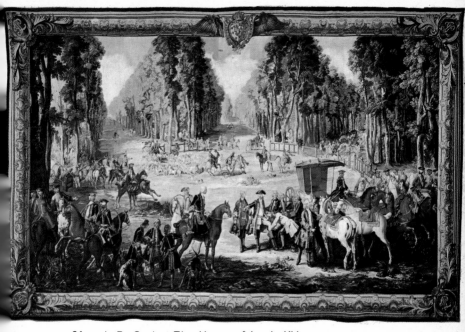

61. J. B. Oudry. *The Hunts of Louis XV.*

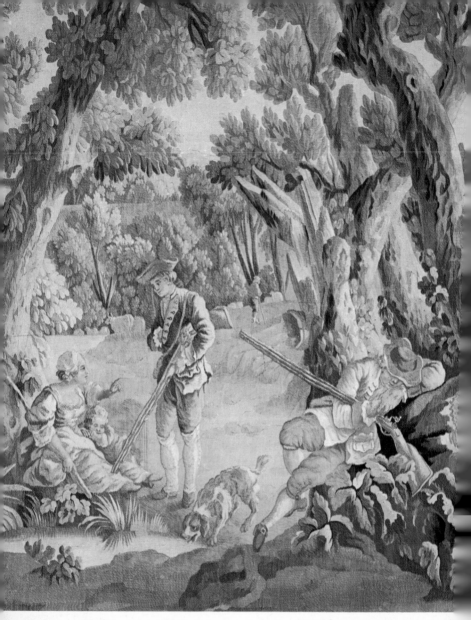

62. *Hunters at Rest*. Aubusson tapestry. Mid 18th century.
Petit Palais, Paris.

noted how, wherever possible, wood was chosen in preference to woven materials.

Another factor detrimental to the art of tapestry-making was the increasing importance given to the role of the painter. In the preceding century, Le Brun had ruled that a tapestry should be judged by its faithfulness to the painter's cartoon: the more it resembled that, the better it was. This principle was insisted upon by Oudry who was for many years director of the Gobelins. Boucher enforced it to the point that, with his always wanting colours that could be reproduced by the weavers, his own paintings acquired porcelain tones, curiously pale, which were soon adapted to his palette. It must be remembered, however, that the art of making tapestry consists not in following the painter's cartoon slavishly but in interpreting it in an original and expressive manner. True, under the iron hand of Oudry, the weavers acquired extraordinary technical experience and consummate skill—in some of the Gobelins tapestries one could pick out up to five hundred different tones —but these experts were losing the originality proper to their craft. Put to the test of time, the tapestries they produced abusing silks and dyes have stood up far less well to shredding than tapestries of much greater antiquity.

Having noted the relative lack of originality in Louis XV tapestries, let us see what their good points were. First of all the technique was astounding; moreover, with famous artists for directors at Beauvais and the Gobelins, the cartoons chosen were of high standard. Those for the celebrated *History of*

Don Quixote woven at the Gobelins from 1728 onwards were drawn, all twenty, by Charles A. Coypel. They have the advantage of presenting a single central medallion illustrating the episode, within beautiful woven *trompe l'oeil* gilt wood frames, which in their turn are surrounded with a background representing flowered damask. For many people today it is precisely these backgrounds—the work of other painters—which give the famous tapestries their great fascination, for it is here the weavers had more scope to show their genius.

On the other hand the tapestries illustrating the stories of Esther and Jason from cartoons by De Troy show the 18th century's passion for mythological or historical scenes which, to modern eyes, seem rather over eloquent and of a courtly style bordering on the melodramatic. More esteemed today are *The Royal Hunts*. Based on nine cartoons by Oudry himself, they were all woven between 1739 and 1745. The best preserved are in the Palazzo Pitti, Florence. The classical hunting scenes, lacking the emphasis which was given to the representations of *le Roi Soleil,* are set in a beautifully rendered background of the Forest of Compiègne and it is these landscapes—drawn from nature—which are among the most successful products of the minor arts in Louis XV's reign.

When Oudry died (1755), he was succeeded at the Gobelins factory by Boucher who had been director of the Beauvais factory. No less active in the field of tapestry than in that of painting, Boucher produced dozens of cartoons for both royal factories. Specially

worthy of note were *The Loves of the Gods, Fragments of Operas, Noble Pastoral, The Story of Psyche, Village Feasts in the Italian Style,* besides many Chinese themes. Like those of the successful wall-tapestries, the latter were also used for the tapestry-work on chairs, divans, screens and other items of furniture. When Boucher took up his post at the Gobelins, the superintendent of the royal buildings, the Marquis de Marigny, brother of la Pompadour, urged him to see that the weavers spared no effort in copying the paintings of the great masters as perfectly as possible.

Although, unlike Beauvais and the Gobelins, the factory at Aubusson enjoyed royal protection in name only, and had no well known painters as directors, it was able to maintain greater independence. Cartoons were selected here and there, at times even from humble local painters, and might then be executed and varied according to the imagination of the weavers. The colours used were, perhaps, not of such a wide range as those available to rival factories, but the very fact that the Aubusson weavers could not afford to use innumerable shades gave their work an incredibly long life. The Aubusson tapestries may have been cruder and more naïve than those of the other factories but today they are sometimes more appreciated for their rather rustic appearance.

SILVERWARE AND OBJETS D'ART

In general, 18th-century French silverware is rare, and it was its intrinsic value that accounted for its

disappearance. To speak only of the period in question, Louis XV, during the financial crisis of 1759, constrained all his subjects to follow his example and melt down their silver. Changing taste and the feckless attitude of society also meant that beautiful silver objects were melted down without hesitation for new models to be made. Add to this the fact that much French silverware was dispersed during the Revolution, and one can see why now it frequently has to be studied from designs or by looking at English silverware which was slightly later but influenced by the French. Curiously enough a third field open to the student is to be found in museums far from France. In Lisbon, for example, there are the great dinner-services made by François Thomas Germain in 1758 for the Emperor Joseph I, an example of how French the courts of Europe were at that time. But the specimens which exist suffice to give us an accurate idea of this aspect of the art of the time.

In silver- and goldware, Rococo was taken to its extreme with its sinuous shapes, almost a revival of Flamboyant Gothic, twisting and convulsed, like a fluted candle hurled into a furnace.

The man principally responsible for the wave of movement in these objects was J. A. Meissonier, who seldom made them himself but instead inspired them with his designs. Like the Slodtz family and Oppenort, he was an *ornemaniste*. It was his fantastic imagination and his taste for asymmetry and the twisted that prompted bitter criticism from the classically minded Cochin. At the same time these very qualities inspired Claude Duvivier to make that

63. Japanese lacquered cache-pot with gilt bronze mount.
1745–1749. Louvre, Paris.

64. Thomas Germain (*c.* 1673–1748). Silver-gilt entrée dish. 1738. Louvre, Paris.

65. Claude Duvivier (first half of the 18th century). Silver candlestick. Musée des Arts Décoratifs, Paris.

63. Japanese lacquered cache-pot with gilt bronze mount. 1745–1749. Louvre, Paris. This exceptional piece belonged to Madame de Pompadour, and came from the Château de Bellevue. At that time good quality Japanese lacquered articles were rare and costly. The bronzework of the cache-pot in this illustration is stamped with a 'C' and crown, the mark of certain taxes between 1745 and 1749.

64. Thomas Germain (c. 1673–1748). Silver-gilt entrée dish. 1738. Louvre, Paris. Thomas Germain was the leading goldsmith of his day. He did not pander to the excesses of fashionable taste, yet his more restrained work was considered the most elegant and imaginative of all. In this famous piece, he used the coat-of-arms of the purchaser as handles for the dish, and contrived an ingenious and original form for the lid.

65. Claude Duvivier (first half of the 18th century). Silver candlestick. Musée des Arts Décoratifs, Paris. Unlike the entrée dish illustrated in Plate 64 this candlestick shows the Rococo at its most exuberant and bizarre. The candlestick was made in Paris about 1735 by the goldsmith Duvivier, from a design by the *ornemaniste* Meissonier, architect and decorator to the King, and one of the keenest advocates of *rocaille* decoration.

66. Celadon vase with gilt bronze mount. Louvre, Paris. Here is an excellent example of oriental art 'revised and corrected' to suit the precious taste of 18th-century collectors: a magnificent Chinese porcelain vase was mounted with gilt bronze and transformed into a jug with a chimera or winged dragon of a vaguely oriental appearance twisting itself round the handle.

66. Celadon vase with gilt bronze mount.

candlestick of clean, sinuous line which is now in the Musée des Arts Décoratifs (Plate 65).

But the dominating figure among silversmiths was Thomas Germain, and he never bowed to the capricious excesses of Rococo. In subscribing to fashionable taste, he did so with moderation and elegance, creating things of great beauty, of meticulous and refined quality and workmanship. An example of this is the Orléans service, so called because it belonged for some time to the family of that name, though now most of it is in the Lopez-Willshaw Collection and in Philadelphia. Then there is the silver-gilt entrée dish to be seen in the Louvre (Plate 64). These are among the most important pieces of silver tableware of all ages, both for the incredible sensitivity and for the highly knowledgeable use of the medium. A search for naturalism is evident in the artichoke which crowns the lid, a little masterpiece of observation.

Apart from F. Joubert, who made the tureen in the Musée des Arts Décoratifs, one of the most noteworthy of Thomas Germain's followers was his son, François Thomas. In his day François Thomas enjoyed unusual popularity and received commissions from the court of the Braganzas in Portugal, and also from the Russian court. Above all his *surtouts* —centrepieces for the table—are most astonishing.

These glimpses of the silversmith's art in Louis XV's day would not be complete without a word about the pairs of figurines representing the chief countries of the world which, fashioned by A. N. Cousinet, once used to brighten the King of Portugal's

table. Then there was the *surtout* which Jacques Roettiers made in 1749 for the Elector of Cologne representing a stag-hunt, with four candlesticks in the shape of robust leafy oaktrees to complete the set. Unfortunately not a single piece remains of Louis XV's heavy gold dinner-service, nor the solid gold *torchères* made by Thomas Germain which the King liked so much that he kept them in his own room. One does not know what became of the silver candlesticks that the *Bien-Aimé* made with his own hands in 1738 at his château at Marly. One might well wonder whether, if he had devoted more time to his kingly duties and less to this fascinating hobby, he might not have prevented the circumstances which later compelled him to deprive himself and, consequently, us as well, of such graceful pieces.

The same might be said of gilt bronze—ormolu—as well, and in fact, some of the craftsmen already mentioned worked in this medium too. There are some ormolu andirons by François Thomas Germain, and similar works by Duvivier and Roettiers. Passement's *pendule* (Plate 69), given to Louis XV in 1753 and installed at Versailles in the room called after it, is a thing of great rarity. Still in perfect working condition, it indicates the hour, the day of the week, the date, the month, the year and the phases of the moon. But, mechanical precision apart, the clock is especially interesting for Jacques Caffieri's magnificent bronzes, perhaps the finest ever made.

One of the most recurrent motifs in the taste and fashions of Louis XV's day was Chinese art, or rather, the version of it then popular in France. In the

67. Candlestick. Musée des Arts Décoratits, Paris.

68. Gilt bronze sconce. Louvre, Paris.

67. Candlestick. Musée des Arts Décoratifs, Paris. Unlike the creator of the vase illustrated in Plate 66 the maker of this candlestick started with a Chinese porcelain statue and achieved a graceful construction of floral inspiration. From a *rocaille* base stem branches of gilt bronze terminating in flowers of Vincennes porcelain and tendrils serving as candlesticks.

68. Gilt bronze sconce. Louvre, Paris. Although dated about the middle of the 18th century, the sinuous line of this sconce with holders for three candles is still in a decidedly *rocaille* style. Despite the tendency towards straighter lines after 1750, craftsmen continued to make articles in the style exemplified by this candlestick.

69. Passement, Danthiou and Caffieri. Astronomical clock. Versailles. This great clock gives its name to the room in Versailles where it stands. Constructed by Danthiou according to Passement's ideas, it was offered to the Académie des Sciences which in its turn presented it to the King in 1753. Its bronzes are among Caffieri's most refined and elegant creations.

70. Gilt bronze barometer. Musée Nissim de Camondo, Paris. Made about 1750, this barometer is still in full Louis XV style. Amidst its swirling forms sit an allegorical figure of Time, two female figures (Venus and Minerva?) and a little Cupid. A barometer of this type often went with a clock to form a pair.

69. Passement, Danthiou and Caffieri. Astronomical clock.

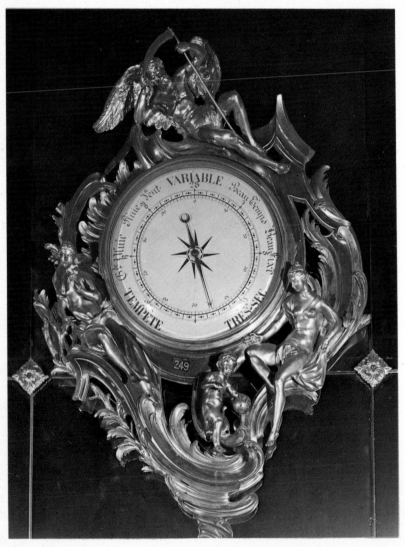

70. Gilt bronze barometer. Musée Nissim de Camondo, Paris.

general mania for collecting *chinoiseries* more than one *grand Seigneur* brought himself to ruin.

These Chinese vases and Chinese figures were constantly embellished, for their simple forms were not ornate enough for the sophisticated taste of the collectors. They were mounted with magnificent *chutes rocailles* where the swirling movements triumph in a harmonious combination of floral motifs in which the craftsmen and *ornemanistes* let their imagination run riot. The magnificent celadon vase in the Louvre (Plate 66) is transformed into a jug by the twining bronze which in a way distorts its shape, crowning it with a chimera, one of those fashionable imaginary monsters which recur as dragons, sirens or griffins on door-knobs or curled to form a hand rest on the arms of chairs. And that little smiling Buddha in Plate 67 sits on a *rocaille* support that sprouts branches which end in candlesticks or bear exquisite flowers of Vincennes porcelain, surrounding him with an enchanted wood which has little to do with China. The same fate overcame many Meissen or Sèvres figurines, and the tables made by Lacroix and 'BvRB' were scattered with little birds and butterflies trapped in minute gilded jungles.

Over the chimneypiece, on top of the *cartels* of bronze, reposed the figure of Time (Plate 70). Life was so pleasant and so sweet that the hours were almost forgotten. No matter how sharp his sickle, it held no fear for the elegant ladies who sat languidly sipping their *thé à l'anglaise*. But the day was near when a different sickle was to show them that time had passed, marking their white necks with red.

LIST OF ILLUSTRATIONS Page

1. Maurice Quentin de La Tour (1704–1788). Portrait of **10**
Louis XV (1748). Louvre, Paris.
2. François Boucher (1703–1770). Chinese Dance. Musée **11**
des Beaux Arts, Besançon.
3. Maurice Quentin de La Tour (1704–1788). Portrait of **13**
Madame de Pompadour. Louvre, Paris.
4. Lacquered papier mâché vase with carved gilt bronze **14**
mounts in the Duplessis style. *c.* 1740–1750. Musée Nissim
de Camondo, Paris.
5. Jacques Verberckt (1704–1771). Boiseries in Madame **20**
Adelaide's music room, Versailles.
6. Jacques Verberckt (1704–1771). Boiseries in the **22**
Cabinet de la Pendule, Versailles.
7. The Council Room, Château de Fontainebleau. **23**
8. Jean Baptiste Oudry (1686–1775). Decorative panels **24**
formerly in a mansion situated at 9 Place Vendôme, Paris.
Musée des Arts Décoratifs, Paris.
9. Box mounted in gold. Musée Cognac-Jay, Paris. **29**
10. Elephant clock. Victoria and Albert Museum, London. **30**
11. B. Guibal (1699–1757) and Jean Lamour (1698–1771). **32**
The Neptune Fountain, Place Stanislas, Nancy.
12. Gabriel de Saint-Aubin (1724–1780). *Party under the* **33**
Orangetrees. Black pencil and chalk on blue paper. *c.*
1750–1755. Ecole des Beaux Arts, Paris.
13. Antoine Watteau (1684–1721). Study of two men. **39**
Red chalk. *c.* 1716. Ecole des Beaux Arts, Paris.
14. Antoine Watteau (1684–1721). *L'Indifférent. c.* 1716. **40**
Louvre, Paris.
15. Antoine Watteau (1684–1721). *Fête Champêtre c.* **42**
1717–1718. Dresden Art Gallery.
16. Jean Baptiste Chardin (1699–1779). *La Brioche*. 1763. **43**
Louvre, Paris.
17. François Boucher (1703–1770). *Mademoiselle* **49**
O'Murphy. Alte Pinakothek, Munich.
18. François Boucher (1703–1770). *Sleeping Diana*. Before **50**
1735, as can be deduced from the way in which the artist
signs his name. Red and white chalk on grey paper. Ecole
des Beaux Arts, Paris.
19. Jean Baptiste Chardin (1699–1779). *The Kitchen-* **52**
maid. National Gallery, Washington.
20. Jean Marc Nattier (1685–1766). *La Marquise d'Aubin*. **53**
Musée Jacquemart-André, Paris.

21. Etienne Maurice Falconet (1716–1791). *Madame de Pompadour as the Venus of the Doves*. Samuel H. Kress Collection, National Gallery, Washington. 59

22. Etienne Maurice Falconet (1716–1791). *Pygmalion and Galatea*. 1763. Sèvres biscuitware. Musée des Arts Décoratifs, Paris. 60

23. Jean Baptiste Pigalle (1714–1785). *Mercury lacing his Sandals*. 1744. Louvre, Paris. 61

24. Claude Michel Clodion (1738–1814). *La Gimblette*. Musé des Arts Décoratifs, Paris. 63

25. Jean Courtonne (1671–1739). Hôtel Matignon. 1721. Rue de Varenne, Paris. 70

26. Jean Lamour (1698–1771). The stairway, Hôtel de Ville, Nancy. 71

27. Inlaid roll-top desk. Private collection, Rome. 73

28. Cupboard-shaped secrétaire. Victoria and Albert Museum, London 74

29. Louis Delanois (1731–1792). Small marquise à gondole. Louvre, Paris. 76

30. A. F. Delorme (active in the second half of the 18th century). Small writing-table. Louvre, Paris. 77

31. Charles Cressent (1685–1768). Commode. *c.* 1749. Louvre, Paris. 79

32. J. F. Leleu (1729–1807). Cupboard-shaped secrétaire. Musée des Arts Décoratifs, Paris. 80

33. Nicolas Petit (1732–1791). Commode. Versailles. 84

34. Jacques Dubois (*c.* 1693–1763). Bureau plat. Louvre, Paris. 85

35. J. B. Tuart (second half of the 18th century). Commode. Private collection, Paris. 87

36. Louis Delanois (1731–1792). Armchair. Louvre, Paris. 92

37. R. Lacroix (1728–1799). Table en chiffonnière. Musée Nissim de Camondo, Paris. 93

38. Transitional style commode. Private collection, Paris. 94

39. F. Reizell (died in 1788). Corner cabinet. Musée des Arts Décoratifs, Paris. 96

40. J. B. Tilliard (1685–1766). Voyeuse. Musée des Arts Décoratifs, Paris. 99

41. Pierre II Migeon (1701–1758). Commode. Musée des Arts Décoratifs, Paris. 100

42. C. Topino (second half of the 18th century). Bonheur du jour. Musée des Arts Décoratifs, Paris. 102

43. J. F. Oeben (c. 1720–1763) and J. H. Riesener (1734–1806). Roll-top secrétaire. Versailles. 103

44. A. Gaudreaux (c. 1680–1751). Commode. Wallace **106**
Collection, London.
45. G. Joubert (1689–1775). Corner cabinet. Versailles. **107**
46. A. Gaudreaux (c. 1680–1751). Commode. Versailles. **109**
47. F. Normand (active from about 1746). Fauteuil de **110**
commodité. Musée Carnavalet, Paris.
48. A. M. Criard (c. 1724–1771). Bureau plat. Private **111**
collection, Paris.
49. Jean Nadal (active in the middle of the 18th century). **113**
Day-bed. Rijksmuseum, Amsterdam.
50. Writing-table with drawers. Victoria and Albert Museum, **116**
London.
51. Louis Delanois (1731–1792). Two armchairs. Biblio- **117**
thèque de l'Arsenal, Paris.
52. J. Dubois (c. 1693–1763). Bureau plat. Louvre, Paris. **119**
53. J. F. Oeben (c. 1720–1763). Secrétaire. Musée Nissim **120**
de Camondo, Paris.
54. Vase of soft-paste porcelain, Sèvres. Musée des Arts **122**
Décoratifs, Paris.
55. Soft-paste porcelain milk-jug and dish. Sèvres. Musée **123**
des Arts Décoratifs, Paris.
56. Saucer and cup with a butterfly-shaped handle in soft- **125**
paste porcelain. Vincennes. c. 1750. Louvre, Paris.
57. Cup and saucer in soft-paste porcelain. Sèvres. c. **126**
1758. Louvre, Paris.
58. Faience soup tureen. Strasbourg. c. 1753. Musée des **129**
Arts Décoratifs, Paris.
59. Faience plate. Sceaux. Musée des Arts Décoratifs, Paris. **130**
60. J. B. Oudry (1686–1755). *The Hunts of Louis XV.* **133**
Gobelins tapestry. 1743. Palazzo Pitti, Florence.
61. J. B. Oudry (1686–1755). *The Hunts of Louis XV.* **135**
Gobelins tapestry. Palazzo Pitti, Florence.
62. *Hunters at Rest.* Aubusson tapestry. Mid 18th century. **136**
Petit Palais, Paris.
63. Japanese lacquered cache-pot with gilt bronze mount. **141**
1745–1749. Louvre, Paris.
64. Thomas Germain (c. 1673–1748). Silver-gilt entrée **142**
dish. 1738. Louvre, Paris.
65. Claude Duvivier (first half of the 18th century). Silver **143**
candlestick. Musée des Arts Décoratifs, Paris.
66. Celadon vase with gilt bronze mount. Louvre, Paris. **145**
67. Candlestick. Musée des Arts Décoratifs, Paris. **148**
68. Gilt bronze sconce. Louvre, Paris. **149**
69. Passement, Danthiou and Caffieri. Astronomical clock. **151**
Versailles.
70. Gilt bronze barometer. Musée Nissim de Camondo, **152**
Paris.